ILLUSTRATION

AN ARTIST'S GUIDE TO ILLUSTRATION ON THE GO!

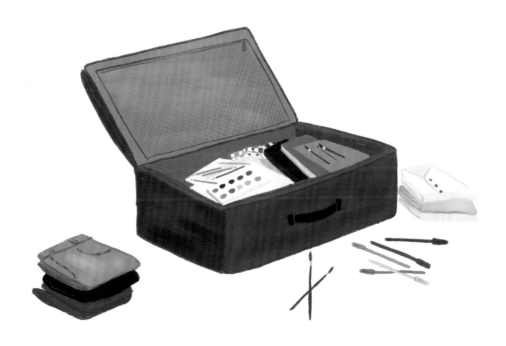

D1411500

Betsy F

Walter Foster

Brimming with creative inspiration, how-to projects, and useful information to enrich your everyday life, Quarto Knows is a favorite destination for those pursuing their interests and passions. Visit our site and dig deeper with our books into your area of interest: Quarto Creates, Quarto Cooks, Quarto Homes, Quarto Lives, Quarto Drives, Quarto Explores, Quarto Gifts, or Quarto Kids.

First published in 2019 by Walter Foster Publishing, an imprint of The Quarto Group. 26391 Crown Valley Parkway, Suite 220, Mission Viejo, CA, USA.
T (949) 380-7510 **F** (949) 380-7575 **www.QuartoKnows.com**

Walter Foster Publishing titles are also available at discount for retail, wholesale, promotional, and bulk purchase. For details, contact the Special Sales Manager by email at specialsales@quarto.com or by mail at The Quarto Group, Attn: Special Sales Manager, 100 Cummings Center, Suite 265D, Beverly, MA 01915, USA.

ISBN: 978-1-63322-699-9

Digital edition published in 2019
eISBN: 978-1-63322-700-2

Acquiring & Project Editor: Stephanie Carbajal
In-house Editor: Annika Geiger

Printed in China
10 9 8 7 6 5 4 3 2

TABLE OF CONTENTS

INTRODUCTION

Illustration is everywhere.
The patterned curtains on your window, the drawings in your favorite cookbook, the decorative coffee mug you use daily—all of these items fill your world with colorful imagery that tells a story. Perhaps your mug is a playful illustration of Paris icons, reminding you of your trip to the City of Light. Maybe the curtains in your kitchen have a tropical flair that whisk you away to the islands.

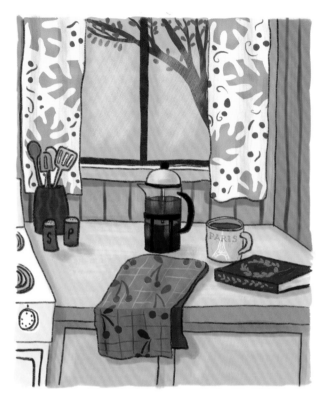

Illustration is art that explains a concept, a process, or a story. It can have a purpose, such as a scientific illustration of a molecule, or accompany the story in a children's picture book. It also can be purely decorative, like a patterned bedspread. Illustrators provide their individual viewpoints on a subject. Instead of just snapping a photograph, illustrators choose a medium (drawing, painting, collage, etc.) and style (abstract, realistic, whimsical, naive, etc.) to represent a topic. The combination of medium and style allows for endless interpretations of a subject.

EXPLORING YOUR WORLD WITH ILLUSTRATION

In this book, I will introduce you to scientific illustration, botanical illustration, portraiture, fashion illustration, food illustration, reportage, and more. We will embark on 12 creative projects that experiment with different media, styles, and techniques to create illustrations that tell the stories of our adventures at home and elsewhere.

Taking the time to illustrate the world around you has many benefits! When I bring a sketchbook to a coffee shop or on a trip, it forces me to slow down and enjoy the experience in a way I wouldn't have otherwise. When illustrating, you need to stop and look at the subject a little more intently, and then figure out how you want to capture the story. Whether you are doodling a quick image or creating a more realistic drawing, the time it takes to illustrate a scene can create a longer-lasting memory.

After years of carrying sketchbooks with me, I have noticed that I see things differently now. A rather mundane scene may catch my eye because of the stunning color palette. A unique sign may beg to be drawn to capture the retro lettering.

ILLUSTRATION STYLES

When first starting out, it's important to experiment with various styles, media, and subject matter to find your niche.

What do I mean by illustration styles? When you look around at the wide variety of illustrated products, you'll notice many overarching styles in how the art is rendered. For instance, you may see a clean-lined, graphic style; a precise, photorealistic style; a painterly, impressionistic style; an abstract, bold style; or a naive, simple style. A style can be used to represent any topic, but some lend themselves better to certain subjects than others.

ILLUSTRATION STYLES

These examples of illustration styles lend themselves best to telling a specific story or viewpoint:

- A quick marker drawing in an expressive style of people in a bustling market is a great way to illustrate the pace, energy, and activity level of the location.

- An impressionistic watercolor, using washes, bleeds, and loose lines, can illustrate a blooming garden. The looseness of the illustration represents how lush and wild the garden is.

- A precise pen-and-ink drawing suits itself well to a botanical illustration of the parts of a flower. This medium is very effective for rendering tiny details.

- A sweet, naive-style drawing in colored pencil can illustrate a children's story.

How does an illustrator find a unique style? Over time, as you build a body of work, you will naturally gravitate toward certain media. Also, many illustrators tend to work best when they focus on subject matter they are passionate about. It's amazing how passion can innately show through in the storytelling of an illustration.

Even seasoned illustrators take time to experiment with new styles and media. As an artist, it's always important to keep growing—you never know where you may end up!

MEDIA & TECHNIQUES

Just as some subject matter lends itself to a certain style, some media are better at achieving a specific look than others. Let's look at the varied media and tools used throughout this book, with some sample techniques that can be achieved with each medium.

PENCILS

There's nothing like a pencil to just scribble down some ideas! The best thing about this medium is that it's usually readily available. Even if you forget every last art supply at home, you can typically find someone with a pencil (and perhaps a napkin) so that you can get your creative ideas on paper.

Graphite Pencils

Graphite pencils are "graded" with letters and numbers to determine the hardness of their core, with the hardest core being 9H. The line is light and faint—the graphite is so hard, it doesn't leave a heavy mark. As the numbers go down, the line becomes darker and heavier. After 2H are H, F, HB, and B in the middle of the scale. Then come the B's (2B, 3B, 4B, up to 9xxB). The bigger the number, the softer the graphite, leaving a heavy black mark.

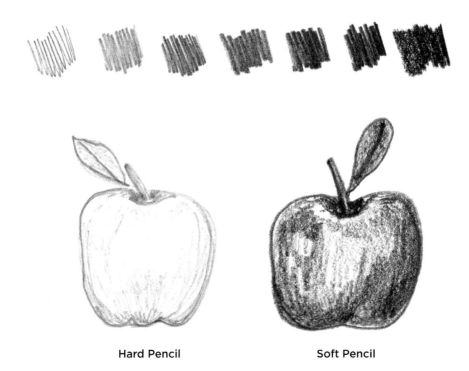

Hard Pencil Soft Pencil

Colored Pencils

Colored pencils follow the same model as graphite pencils in terms of softness, but typically, a pencil brand will describe the core as soft, medium-soft, or hard. Just like graphite pencils, colored pencils are easier to control than a brush and give you more precision. They also come in a rainbow of colors. This example shows how you can shade and blend with colored pencils. The left banana has no shading, and the right banana has shading and blending details that add form and dimension.

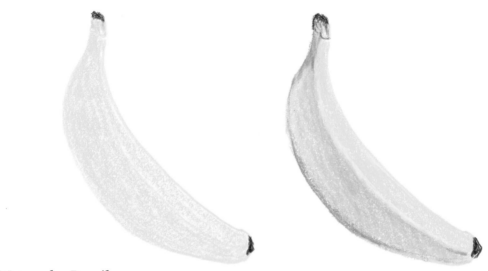

Watercolor Pencils

Watercolor pencils are versatile, because they are like two mediums in one—pencil and watercolor! They are also very easy to travel with and don't make a mess. Since this medium behaves like a pencil, it's great for people who like to "draw" their subjects versus painting with a brush. With just a few brushstrokes of water, the drawing can soon become a painting. This step-by-step example shows how to use watercolor pencils. The first two steps are just watercolor pencil. In the final step, the addition of water turns the grapes into a painting.

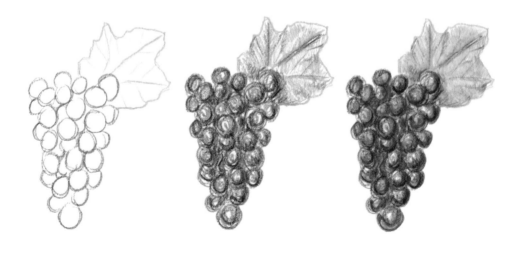

BLACK PEN

One of my favorite drawing tools is a black pen. Often, I use my black pen with watercolor. I love the combination of a clean pen line with the looseness of watercolor. Black pens come in varied weights and even "brush" pens. The weights determine the thickness of the line. The thinner the line, the more detailed the art can become.

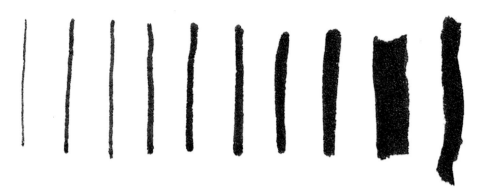

You can also buy a fountain pen and accessorize it with various inks and nibs, which vary in weights/stroke sizes to produce different line qualities. For both fountain pens and regular black pens, it's important to use waterproof, archival-quality ink. This ensures that if you add paint to the drawing, the ink won't bleed or fade. Here is an example of a simple black ink drawing of a lemon in varied ink weights. The thickness, or weight of the line, shows detail, shadow, and depth.

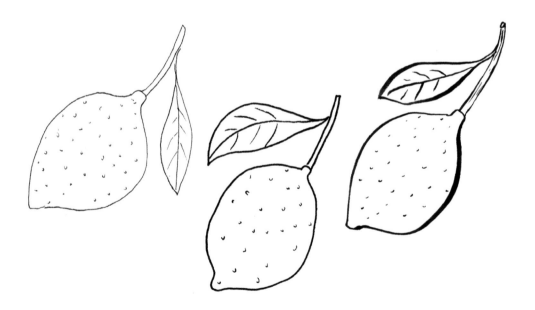

PAINT

I've been painting for as long as I can remember. The three media I gravitate toward are watercolor, gouache, and acrylic. These are all water-based paints, meaning they are thinned with water. The main differences between the three are opacity, thickness, and ability to "reconstitute" (rework once dried) by adding water. Being water-based, these media are great to use while traveling; they're simple to set up and clean up.

Watercolor

Watercolor is my go-to paint. I can achieve such a wide variety of looks with this medium simply by varying the opacity of the pigment, depending on how much water I add. With a lot of water, I can enhance translucency (i.e., the white of the paper shows through). With little water, I can create bold, vivid strokes. There are also endless possibilities when playing with wet or dry paper and a wet or dry brush!

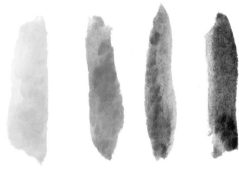

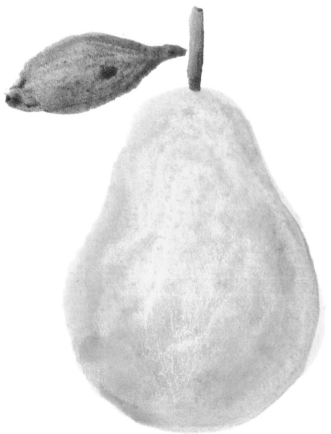

Gouache

Gouache is another water-based paint that acts like watercolor, but is more opaque. I like to use gouache when I want to achieve less of a "washed/watery" feel and would rather build up my colors with a more layered effect. Gouache can also produce vivid colors and may be reworked by adding more water to the page, even after it dries.

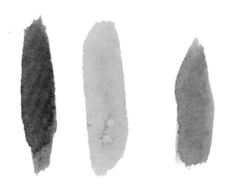

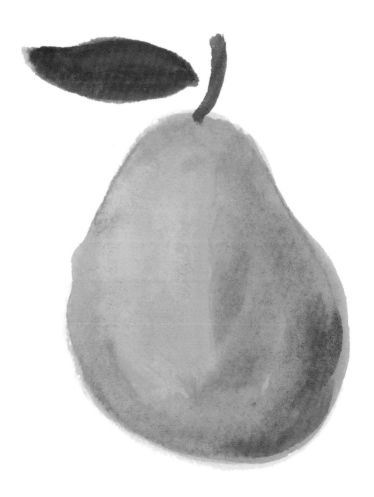

Acrylic

Acrylic is the thickest of these three paints. It is still water-based, but it has a thicker emulsion mixed into the pigment to give it more body. With acrylics, the more water you mix in, the more of a wash you can achieve. In contrast, when paint is used directly from the tube, it is extremely opaque, so it is well suited for playing with opacity and layering for thickness. Unlike watercolor and gouache, however, once dry, acrylic paint is permanent.

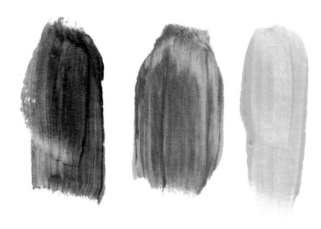

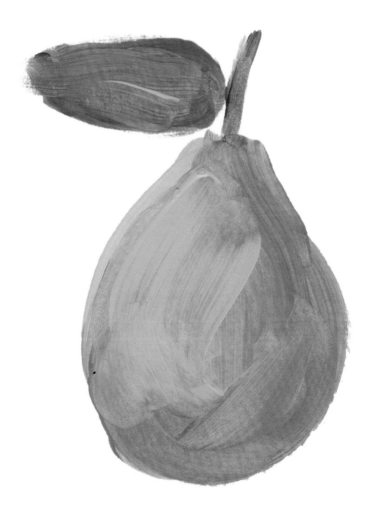

MARKERS & PAINT PENS

Markers can be either water-based, alcohol-based, or paint-based. Water-based markers are great when you want the saturated color of a marker but the ability to blend with water. But, as the name suggests, when water is added, the ink bleeds. Alcohol-based markers dry quickly and are permanent. They also have bright hues and allow for blending. Paint-based pens are just that: pens with paint inside, typically water-based. Once dry, paint pen is permanent. Another great aspect of paint pens is that they can be used on a variety of surfaces.

In general, use pens to illustrate if you prefer to draw versus paint with a brush (although some pens do have brush tips). With any of these options, it's easy to draw precise lines in a rainbow of vivid colors. Like black pens, many markers and paint pens come with various nibs, from fine points to chisel edges.

Below are some simple illustrations made with each type of marker so you can compare the differences.

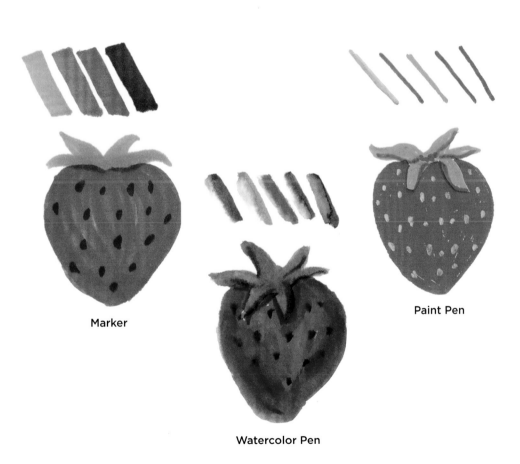

Marker

Watercolor Pen

Paint Pen

OTHER MATERIALS

Sketchbooks & Paper

When buying a sketchbook, look for one with the right paper weight and texture for your preferred medium. For instance, if you like to draw in marker, mixed media paper works well, because the ink won't bleed through to the other side. If you like watercolor, find a sketchbook with watercolor paper so that the paper doesn't crinkle or buckle with the addition of water. If you like to work with mixed media, choose the heaviest weight possible.

Sketchbooks also vary in size. Personally, I love a wide variety of sizes. I love taking a small, pocket-sized sketchbook with me wherever I go. I use larger sketchbooks when I'm at home and can spread out.

You can also purchase single sheets of art papers. There are many beautiful papers on the market; your choices are endless. Again, when picking single sheets, keep your medium in mind.

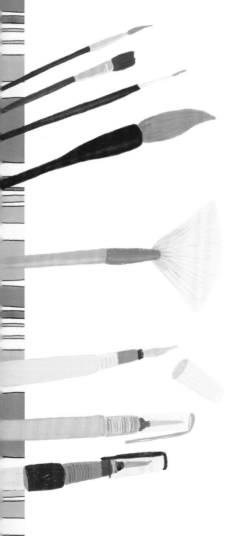

Brushes

There are dozens of different brushes available in the marketplace—it can be overwhelming to choose. When selecting brushes, consider your medium. For instance, if you like to use acrylic paint, you should purchase synthetic-hair brushes, which can withstand the caustic nature of the paint. You should also consider the shape and size. If you like big, bold brushstrokes, stay clear of tiny brushes. In contrast, if you love painting intricate details, you need a thin, small brush.

Brushes are made with different hair types: natural, synthetic, or a combination. The types of hair vary in flexibility and strength, as well as how much medium they hold.

I suggest getting at least a few water brushes. These are absolutely my go-to, especially when on the go. These brushes have a reservoir for water, and when squeezed, the water drips down into the brush. From there, you can use any water-based medium.

Tape, Glue & Scissors

It's always helpful to have some scissors, tape, and glue in your tool chest of supplies. I find that small, sharp scissors are best for collaging. If you plan to use scissors while traveling, be sure to pack them in your checked luggage!

As with most art supplies, there is a wide variety of tape options. Have a roll of clear archival tape handy, but experiment with different washi (or decorated) tapes for enhancing an illustration or a collage.

I'm partial to glue sticks over liquid glue, mostly because they are so easy to travel with. A glue stick also rarely causes the item being glued to buckle or crinkle. Look for an archival glue stick that doesn't change colors when dry or lose its stickiness over time.

USING FOUND MATERIALS

Collaging with found materials from your adventures at home or traveling is a great way to add dimension, interest, and context to your illustrations. Found items may not only represent what you did while exploring, but also bring up a wide variety of other memories, such as where you were when you found the object, who you were with, or what made you stop to pick it up.

Here's a list of possible items you might find in your travels at home or abroad, and some creative ways to integrate them into your illustrations or sketchbook.

Pamphlets & Brochures
Pick up a few of these from the places you visit. Cut out and collage images or words that remind you of your experience. Feel free to doodle, paint, or draw on them to enhance the images.

Ticket Stubs
Keep all your ticket stubs from your trip. This ephemera is a great addition to your sketchbook!

Receipt
A receipt may seem like a mundane piece of trash. But instead of throwing it away, tape it into your sketchbook and draw the item you purchased next to it!

Packaging, Wrapper, or Shopping Bag
A foreign candy wrapper, a box top from packaging, or a printed shopping bag can make a colorful addition to your sketchbook. Add a sketch of the food item or object that came in the packaging.

Newspaper
I love to bring home a couple pages from a foreign newspaper. Even if I can't read the language, the newspaper has the date when I visited, headlines for the news of the day, and photos and advertisements from the location. You can clip out articles or keep the whole page and put in your sketchbook, but you can also sketch on it or cut it up and use it to collage (see page 123).

Local Magazine
Many cities have a local magazine dedicated to the area. Pick up one on your travels and use it to collage in your sketchbook.

Found Papers
A discarded list, a patterned piece of paper, a scrap of a note...although you may not know the context of these items, they can make great elements to collage and add interest to your illustration.

Business Cards
I love to collect business cards. Some are so well designed, they become art on their own. I tape them into my sketchbook and sketch the hotel, restaurant, or even the person that it came from—a great memory, and handy to keep for future reference.

Paper Napkins or Coasters

A paper napkin or coaster from a bar or restaurant is a fun found object to keep. It usually has the logo of the place, so it will remind you of where you were. Jot down a quick journal entry on the napkin to remember your experience, or draw a sketch.

Key Card

Yes, you're supposed to return the key card from a hotel when you check out, but I can't tell you how many times I've mistakenly come home with one. If you experience the same thing, use them as a fun found object for your sketchbook!

Photograph

Print out a photo from your phone or camera and paste it into your sketchbook. Use a paint pen or marker to doodle on top of the image.

Nature

One of the best types of found objects is nature itself! A pressed flower, a colorful leaf, or a petal makes a perfect addition to your sketchbook, alongside a sketch of the location. Or, if you're feeling creative, use a paint pen to doodle on the nature item. Never remove items that are imperative to a habitat. Familiarize yourself with local laws before removing anything.

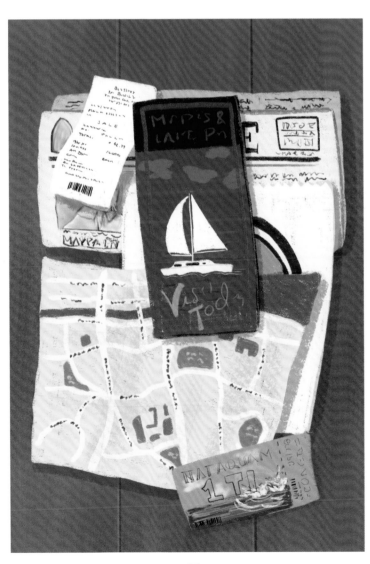

EXPLORING COLOR

Life is colorful! No matter the season, every day offers up a new color palette. Whether it's a moody, foggy morning and the street you live on is muted by the white mist or a vivid fall afternoon road trip when the orange and red leaves of the trees shimmer in the dwindling sunlight, the color of the world around us can play a large role in the memories of daily life and travels.

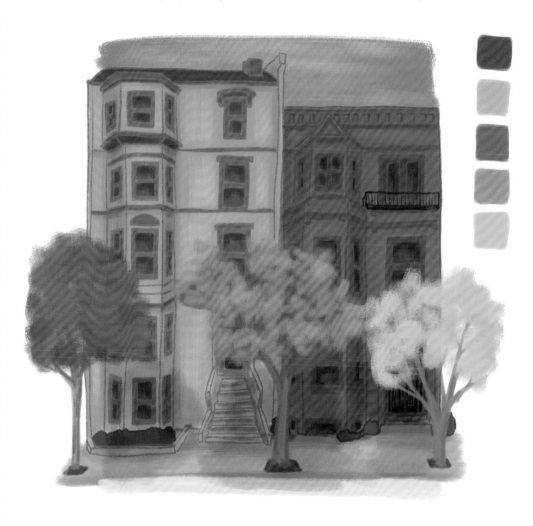

A road trip I took from New York City to Boston some 20 years ago still has a rich fall color palette associated with it in my mind. From the red-browns of the brownstones in Brooklyn and Back Bay to the golden yellows and bright oranges of the trees lining the highway through Connecticut, I'm amazed at how subconsciously color plays such a large role in my memories.

COLOR & MOODS

The colors of a day can also affect our mood. A foggy morning for me is always a sign to put on an extra sweater, heat up a cup of coffee, and nestle in my house for some drawing time. The act of bundling up and staying put on a foggy morning is like an imitation of what's happening outside. The muted, cool colors, engulfing fog, and quiet of the street put me in a calm mood, eager to stay warm and get lost in my own creative thoughts.

Red: exciting, energizing, alive, passionate, dramatic, powerful, romantic, adventurous, elegant

Orange: fun, whimsical, happy, optimistic, sociable, spicy, exotic

Purple: magical, spiritual, romantic, sensual, dramatic, intriguing, royal, rich

Yellow: cheery, happy, sweet, hope, joy, optimism, energy, vitality

Blue: quiet, patient, calm, trusting, heavenly, peaceful, faithful

Green: natural, refreshing, soothing, renewal, youthful, luxurious

Turquoise: infinite, faithful, cool, compassionate, tropical, ocean

This color palette evokes a foggy morning in Nantucket.

This palette evokes a tropical day in Miami.

MINI PROJECT:
FIND THE COLOR PALETTE OF YOUR DAY!

Take a few quick photos with your phone throughout your day. In the evening, look at them all together. Find five colors that are in each photo. Is this color palette a good representation of your memories for the day?

ACTUAL COLOR PALETTE VS. IMAGINARY COLOR PALETTE

Determining the color palette from your day or from a trip is a great way to begin an illustration. Talented illustrators keep a color palette in mind or decide on a palette when starting any new project. The color palette, combined with the subject matter and medium, plays a key role in the message you want your illustration to deliver. A fun way to add pizazz and interest to an illustration is not to be literal to a scene, but to create an imaginary palette. This can offer a new meaning to something you have experienced.

One afternoon in Tucson, Arizona, I took a walk with my sketchbook on the trails behind our hotel. As I sketched saguaro cacti and marveled at the arid landscape, I soon realized how hot it was. It felt only natural to pull out a bold set of colored pencils and paints to capture the scene.

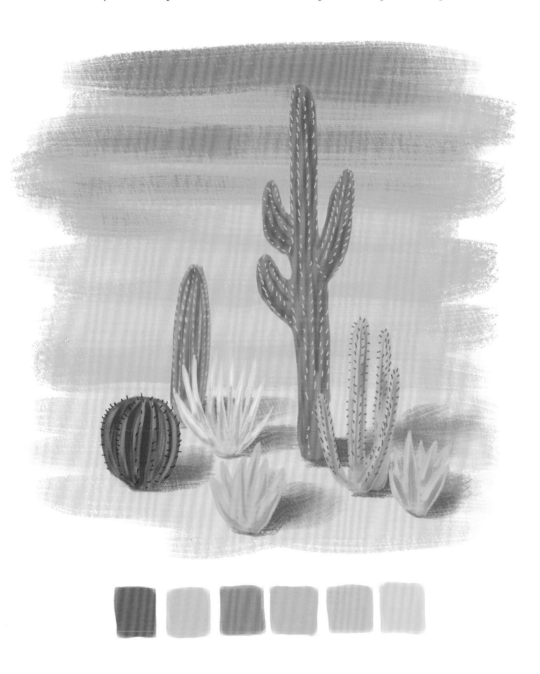

COLORS AT HOME

Some communities have a restriction on the colors they can paint their houses. This limited color palette creates a harmonious look to the neighborhood.

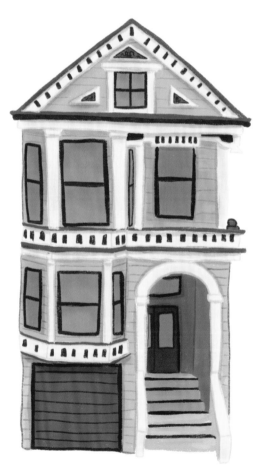

Some cities allow people to be very expressive with how they paint their homes. This approach creates a unique and individualistic feel. For example, in San Francisco, the ornately decorated Victorian homes are the perfect base for a decorative and colorful palette. Each house has an individual history and story, yet as a whole, they provide the personality for which the city is so well known.

COLORS WHILE TRAVELING

At many of the places we visit, the colors alone are one of the most memorable aspects. Once you get in the habit of paying attention to the color palette wherever you are, you'll be amazed at how colorful your world becomes!

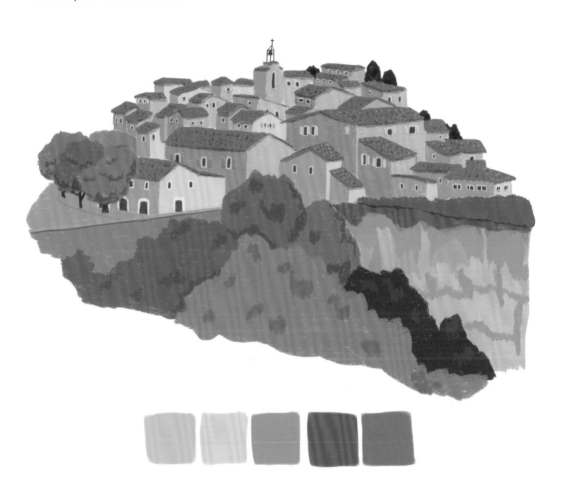

TIP

Reserve a few pages of your travel sketchbook just for color palettes you encounter along your journey. You'll be amazed at how they will help you recall some of the experiences from your trip.

MAKING ART ON THE GO

When I'm heading off on a big trip, I tend to get overly excited. I'll start piling all of my art supplies next to my suitcase until it becomes clear that I've gone overboard! Whether you're heading off to your local park or flying to Europe, the key to making art "on the go" is to keep it simple and pack light. Being laden down with supplies doesn't necessarily equate to better art. Usually it only takes a few supplies to have fun and make good art. This section provides some easy solutions for making art every day.

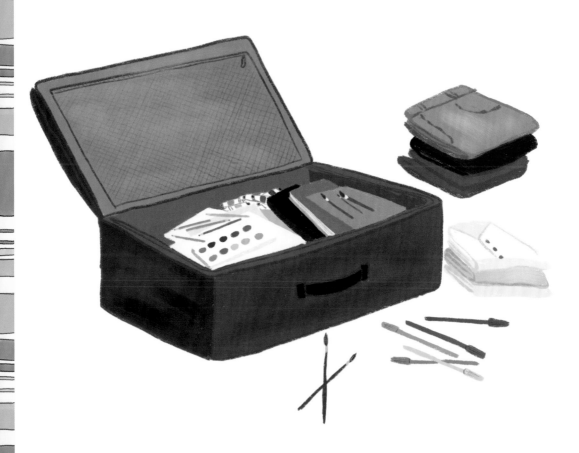

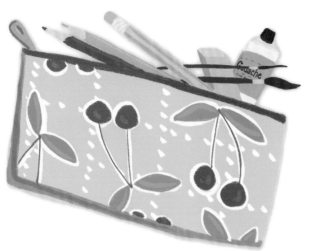

SMALL "ON-THE-GO" BAGS TO FIT YOUR MOOD

The thing I love about illustration is that it is media independent. I have my favorite media to work in, but depending on my mood and what I'm trying to portray, I enjoy switching it up and creating art with a new look. To make this process as easy as possible, I've created a few art-on-the-go bags with my supplies. Let's take a peek at the bags I have created and the supplies within each.

Watercolor on the Go

I only need one water brush on an outing, typically with a medium-to-fine tip. If you're traveling by plane, be sure to put your water brush in a resealable plastic bag in case the change in pressure makes the brush leak. I also pack black waterproof markers—a fine point and a medium point—as well as my travel watercolor set that contains enough colors for me to mix any shade I want. I pack a few paper towels in case I need to blot my artwork or dry off an oversaturated brush.

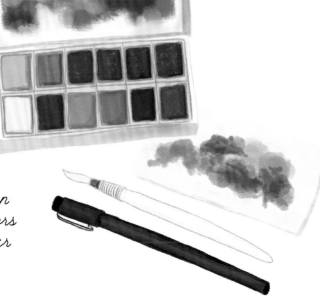

TIP

Make sure to use a waterproof marker when working with watercolors to ensure that the marker doesn't run.

Colored Pencils on the Go

For a generic on-the-go bag, I pack about 10 pencils. I try to take at least two shades from each color on the wheel, as well as two to three neutral colors for skin tones and items seen in nature. Be sure to include a small pencil sharpener too. If I want to limit myself even more, I choose a color palette. (See "Exploring Color" on page 18 for more details on color palettes.)

Pens & Markers on the Go

This is one of the simplest on-the-go bags I have. I often omit colored markers and just bring two black markers with me—a fine tip and a brush marker. I find keeping it as simple as just one marker and a small sketch-book actually encourages me to draw more!

SKETCHBOOKS

Just like with art supplies, one can go overboard with sketchbooks! At home, I have several sketchbooks of different sizes and paper weights. The heavier papers are perfect for gouache and watercolor, while the lighter ones are great for colored pencil sketching, light markers, and scribbling down ideas.

I like to grab the sketchbook that works well for what I want to draw or paint. Likewise, when on the go, it's all about size and accessibility. I love smaller sketchbooks that can easily fit in my purse. I'm also a fan of accordion-style sketchbooks (sometimes called "concertina style") for trips.

TIP

Prevent new sketchbook anxiety by having two or three sketchbooks going with various projects in progress at one time. Switch back and forth between them depending on your mood. Once fully complete, a sketchbook can be an assortment of media, drawing styles, and scribbled notes, and it will still feel like a cohesive accomplishment of creative ideas.

KEEPING COMFORTABLE WHILE SKETCHING

Small Stool

One of my favorite on-the-go items to bring is a handy fold-up stool (tripod style). These types of stools are typically very light and come with a strap to sling over your shoulder. They are also inexpensive and fit easily into a suitcase. My back has thanked me many times for having this handy!

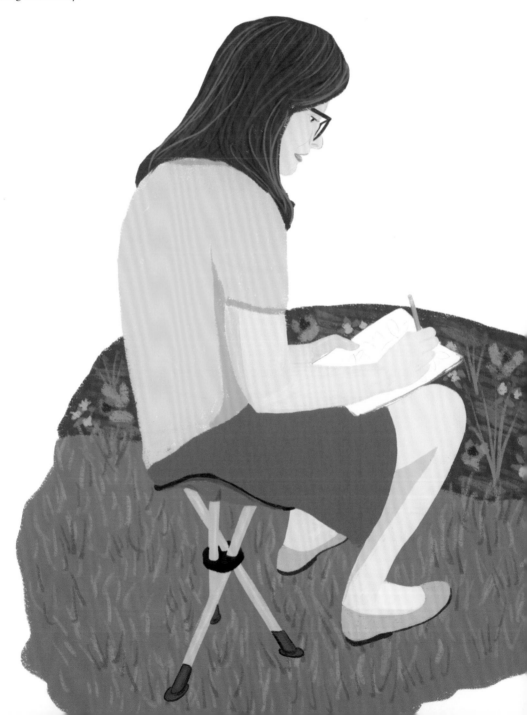

Sketching on the Go

Depending on who you're traveling with, you may or may not have all the time you'd like to sketch while on the go.

When my art time is restricted, I like to use my phone for snapping pictures while I'm out and about. I'll also carry a pencil or pen for sketching quick ideas and notes. Once back at the hotel, I enjoy spreading out with more room to create. Although it's fun to illustrate on location, it can be quite relaxing to wind down at the hotel and create a few drawings.

Project 1:
HOME SWEET HOME

While my head is swirling with wanderlust, counting down the days until my next travel adventure, my heart is always fulfilled at home. I'm lucky to be able to work from home as an illustrator. Although I take breaks during the day, I'm amazed at how much time I can contentedly spend in my house. It truly is my home sweet home.

Media: black ink, watercolor

What makes your home feel just right? Do you have a favorite chair you love to sit in and sip your tea? Do you always read on the couch with a certain blanket wrapped around your legs? Perhaps you love to cook and spend hours in the kitchen, your favorite room in the house.

To create this project, you'll draw your home, surrounded by your favorite items, with black waterproof pen. Then, you'll add some loose watercolor washes and color to soften the feeling of the stark black lines and give your illustration warmth and friendliness. The end piece will be the perfect keepsake to hang in your home!

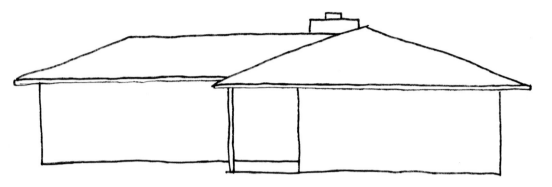

STEP 1: DRAW YOUR HOUSE

First, take a look at your home and break it down into simple shapes. I live in a classic post–World War II ranch house. It's long and rectangular with a low roofline. Draw the basic shapes to form the house in the center of the paper.

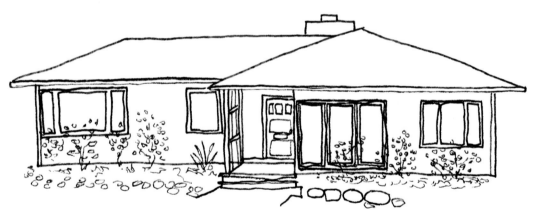

STEP 2: ADD HOUSE DETAILS

Now add more shapes to indicate windows, shutters, the front door, and so on. Add any simple, distinguishing landscaping that may be in front of your house. Don't go overboard. The key to this illustration is not to end up with an architectural rendering of your house, but instead, a sweet, simple impression.

STEP 3: FIND YOUR FAVORITES

Now is the fun part—surrounding your home with your favorite things! Choose a selection of household items that are meaningful or sentimental: Sketch all your options, and choose the ones you like the best.

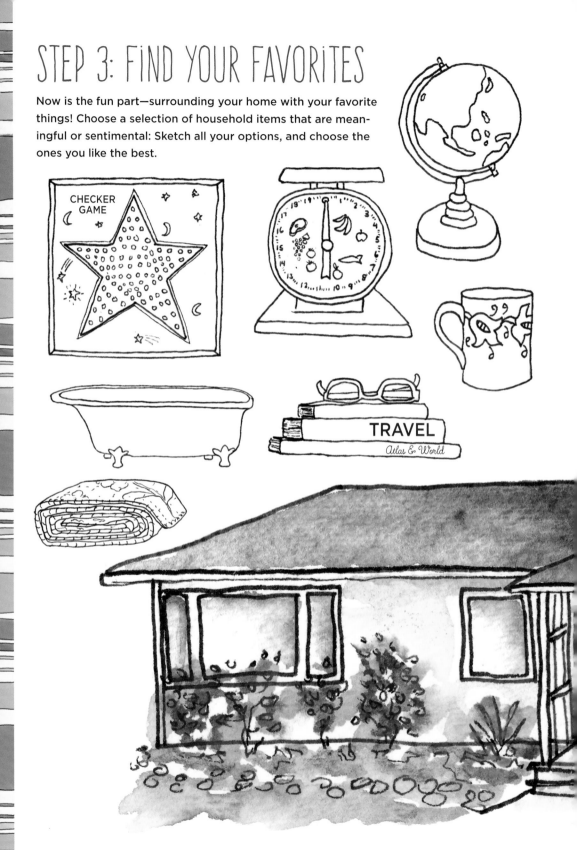

STEP 4: ADD SiMPLE COLOR WASHES

Pick a color palette that makes you think of your home. You can be as literal or creative as you'd like. Perhaps your house has a relatively neutral palette. Instead of painting with beige, you might pick bright colors with pop that suggest the way your home makes you feel versus how it actually looks (see "Color & Moods" on page 19).

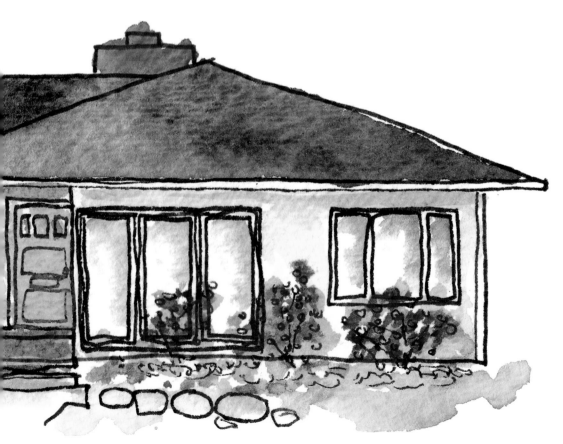

Next, add color to the
items and things around
the house.

Don't be precious with your watercolor
marks. Let the color spill over the lines to
give the illustration a worn-in and loved
feeling, like your own home sweet home.

STEP 5: ADD A SIMPLE FRAME

Draw an oval around your entire illustration. Next, add simple leaf shapes and a few berries. Add splashes of colors to the leaves and berries to finish the frame.

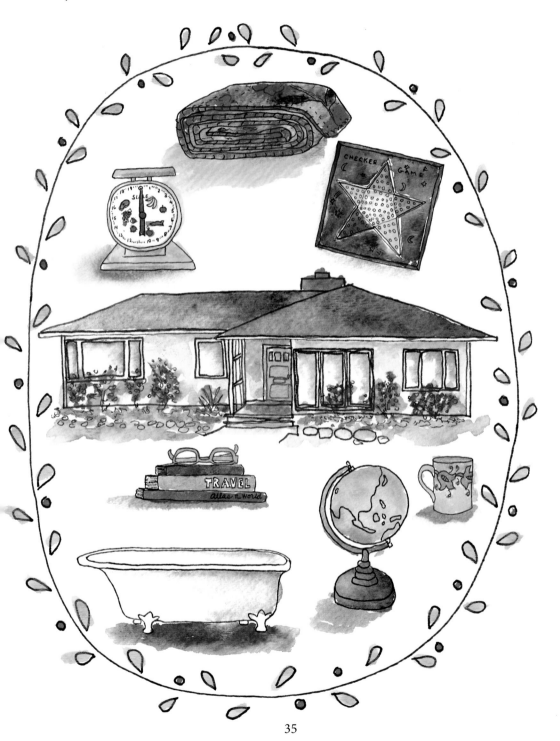

Project 2:
PET PORTRAIT

Having pets is gratifying. I have lived with dogs, cats, fish, and hamsters—all with their individual personalities—and each has become an integral part of my family. For this project, let's illustrate these memorable personalities. We'll use colored pencils and take cues from traditional portraiture painting, but we'll add an illustrative twist, with more cartoon/caricature styling and creative coloring.

Medium: colored pencil

We rescued an obese golden retriever named Ruby. Despite her weight, she always wanted to be part of the action. After a year of dieting and exercise, she got down to a healthy weight and became much more mobile, which worked in her favor so she could be ever present at our feet, begging for love and, of course, food.

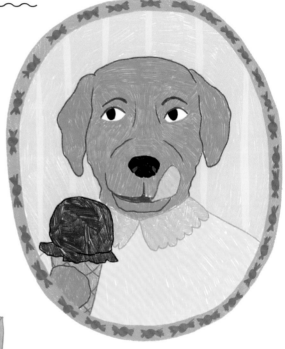

It's not just bigger pets that exude personality. I once had a betta fish named Chuck who seemed relatively aloof at first. He'd swim in a nonchalant manner, back and forth in his bowl, but as soon as I sat down near him, he'd stop and come to the edge.

SIMPLE PET FACES

Let's start by drawing a few simple pet faces. For each face, start with a simple shape, and then add
the necessary eyes, ears, nose, and mouth.

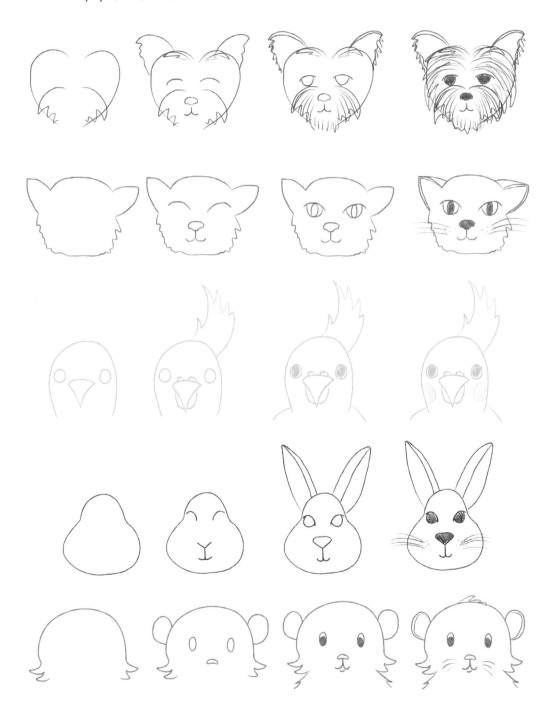

ADD EXPRESSIONS

Here's a second set of those faces now showing a little more personality with their expressions. Just adding a simple smirk to a smile line can give more individuality to a pet!

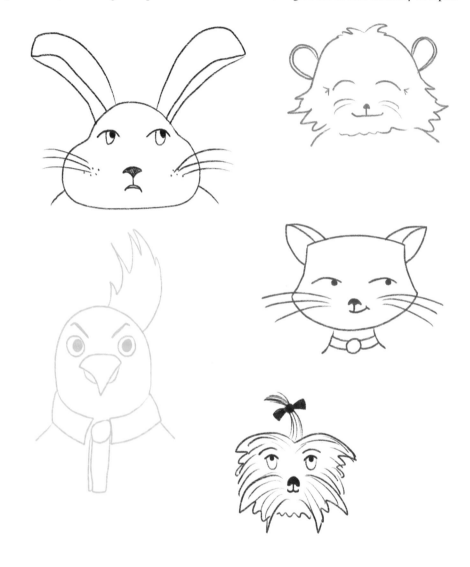

TIP

It's amazing how a very simple illustration can be a great representation of your pet. Don't worry about trying to make a photo-realistic version of your pet. Once you add an expression and accessories, your pet's likeness will shine through.

CAPTURING A PET'S PERSONALITY

If your pet were a person, what would its personality be like? A friendly grandmother who knits all day? A rambunctious kid who plays endless hours of baseball? A young girl enamored with glittery unicorns and pink bubble gum? Write a list of ideas about who your pet might be if he/she were a person.

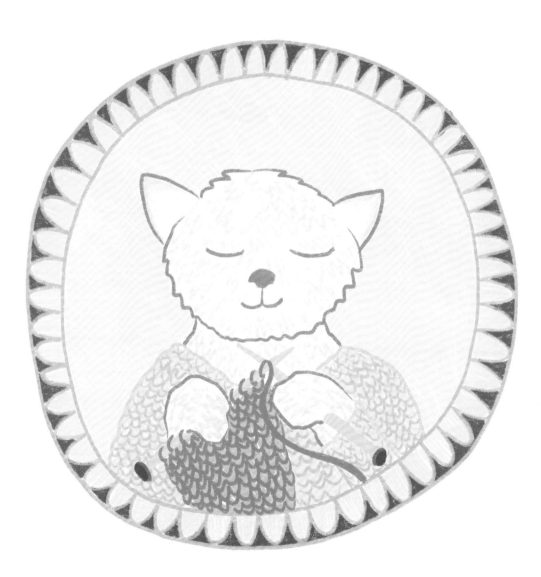

Now, brainstorm a list of accessories that your pet's personality may wear or own—items from this list can become be great fodder for your portrait.

OUTFITS & ACCESSORIES

- Bow tie, tie, or scarf
- Shirt (rock concert T-shirt, vest, poet shirt, turtleneck, cardigan, fisherman's sweater, etc.)
- Pocket watch, wristwatch, smartphone
- Hat (top hat, beanie, fascinator, cloche, baseball cap, etc.)
- Glasses (spectacles, cat-eye glasses, reading glasses, sunglasses, big framed glasses, monocle, etc.)
- Hair accessories (bow, headband, scarf, etc.)
- Other accessories (purse, umbrella, stuffed toy, blanket, chair, etc.)

Now that you've practiced drawing simple pet faces and brainstormed the personality, put them both together and create a portrait. I'm going to draw my sister's chocolate lab, who lived in Colorado—his enthusiasm for the great outdoors was infectious!

STEP 1: DRAW A FRAME

Make a light line to draw the frame around your portrait. Choose a frame style that matches the personality of your pet. I'll draw a wood frame for an outdoorsy look. Color in the details of your frame with colored pencils.

STEP 2: DRAW THE PET'S PORTRAIT & ACCESSORIES

Start with a light gray pencil to lightly draw your pet's portrait, including accessories. This illustration is a light-hearted caricature, so don't worry about imperfections—these will only add to the charm! Once you're happy with the overall layout, use your choice of colored pencil to go over the lines with a heavier mark.

Colored pencils are a great medium for illustrating animal friends—especially furry ones! Quick lines or even just scribbles with a colored pencil make great fur textures.

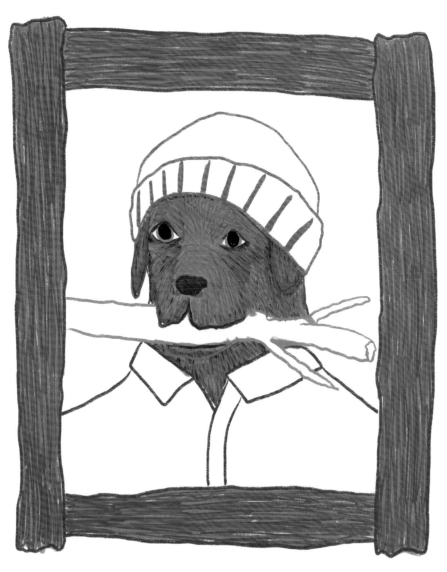

STEP 3: FINAL COLOR DETAILS & BACKGROUND

Give yourself the freedom to experiment with color and stray from the actual fur color of your pet. Color can also add that extra element your portrait needs to convey your pet's true personality.

Don't forget to add a background. You could use a solid color or be creative and add a simple plaid, like one might find in a woodsy cabin, to match an outdoors-loving dog!

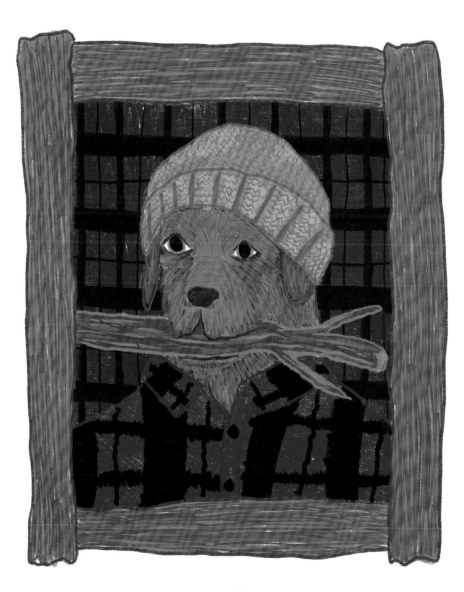

Project 3:
GARDEN

For this project, let's head out into our gardens or the park and become botanical illustrators! We'll use a free and easy doodle style to show off all the blooming flowers, grasses, and birds. Let's start with some simple doodles of flowers using basic shapes.

~~~~~~~~~~~~~~~~~~~~~~~

**Media:** black pen & markers

~~~~~~~~~~~~~~~~~~~~~~~

WHAT IS DOODLING?

I'm sure you've done it a thousand times before—those scribbles on the notepad while on the phone, sitting in a boring meeting, or listening to a long lecture. Often doodles are just meaningless mark-making. Sometimes we doodle more representational items: a heart, a house, a tree. Usually when we doodle we don't give much thought to the outcome—it's a way for us just to "space out."

Studies have shown that doodling helps us maintain some level of attention and not completely turn off or daydream. In full daydream mode, we lose context of the activity at hand and remember far less. So, doodle away—it's good for you!

～～～～～ TIP ～～～～～

If you don't have a garden, grab your sketchbook and head to your nearest park or local nursery to capture some blooming flowers.

～～～～～～～～～～～～～～～～

CIRCLES & OVALS

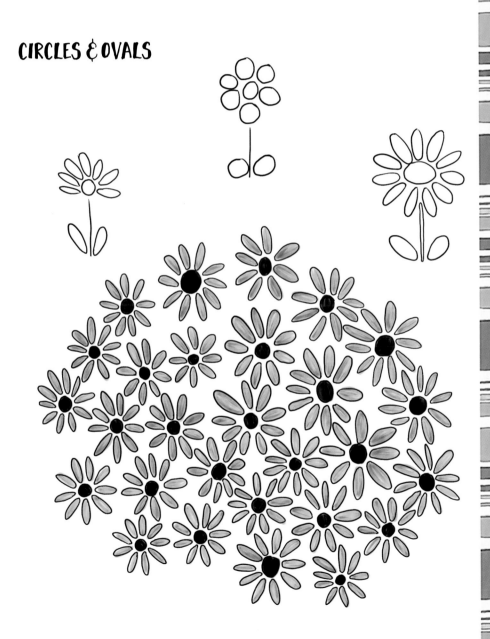

RECTANGLES & SQUARES

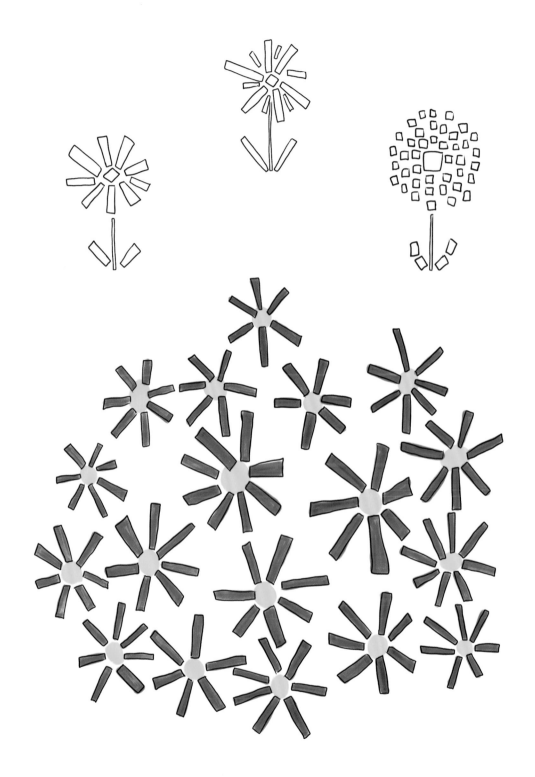

TRIANGLES

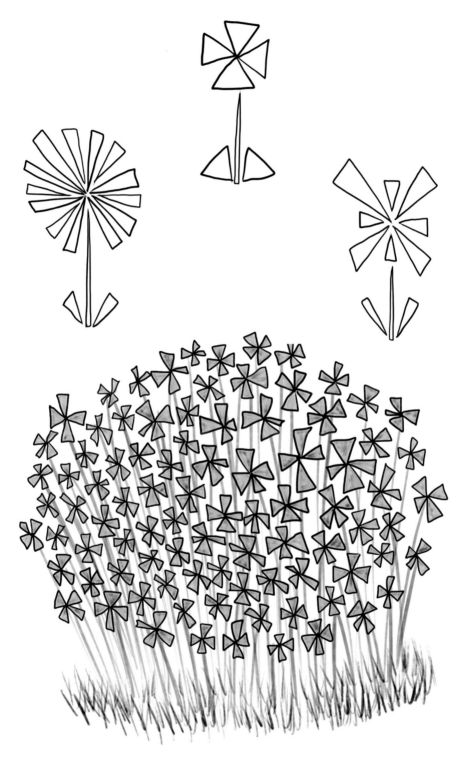

A garden can be filled with many other things too. Here are some simple doodles for other things you may find.

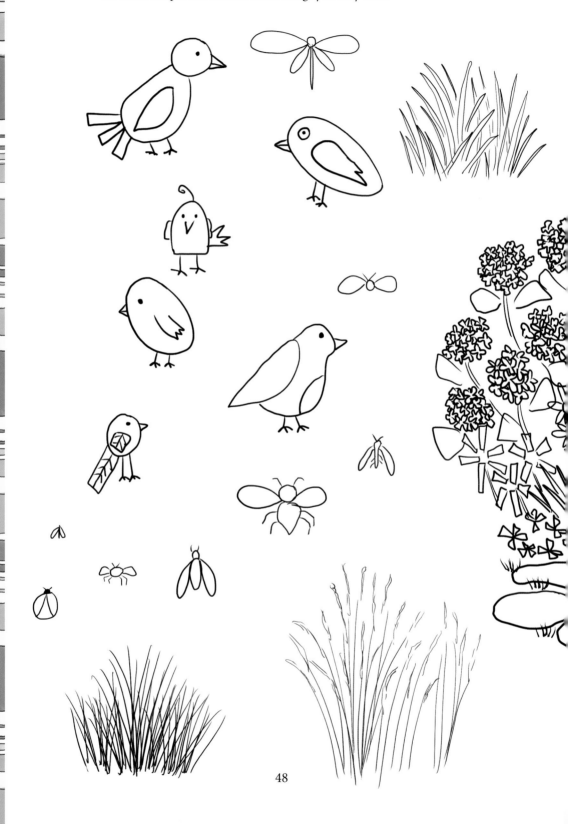

Put it all together and doodle a botanical
illustration of your garden. Build up from the
bottom, starting with a stone path. Using the
doodles you practiced earlier, add layers of
flowers to fill out the garden.

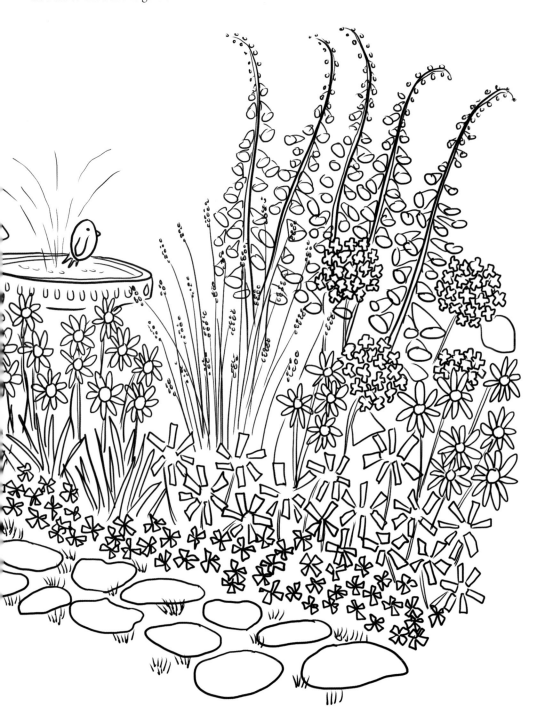

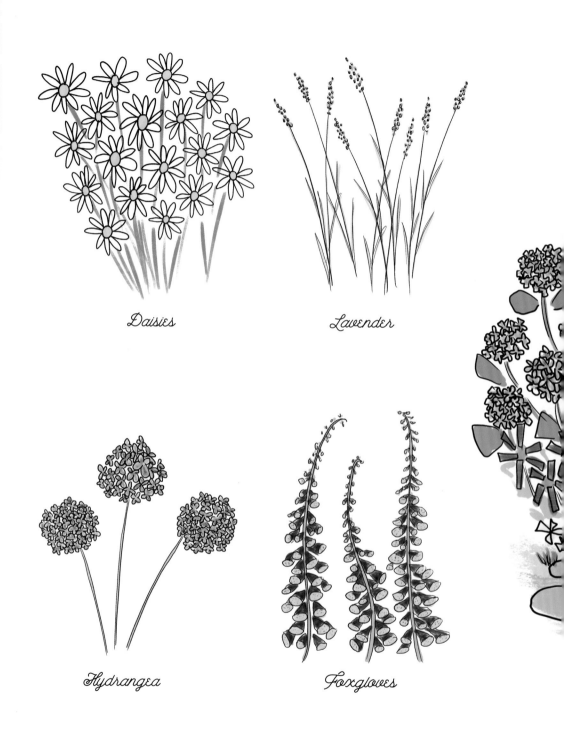

Daisies

Lavender

Hydrangea

Foxgloves

Then add bright color using everyday markers.
This garden illustration is a doodle worth framing!

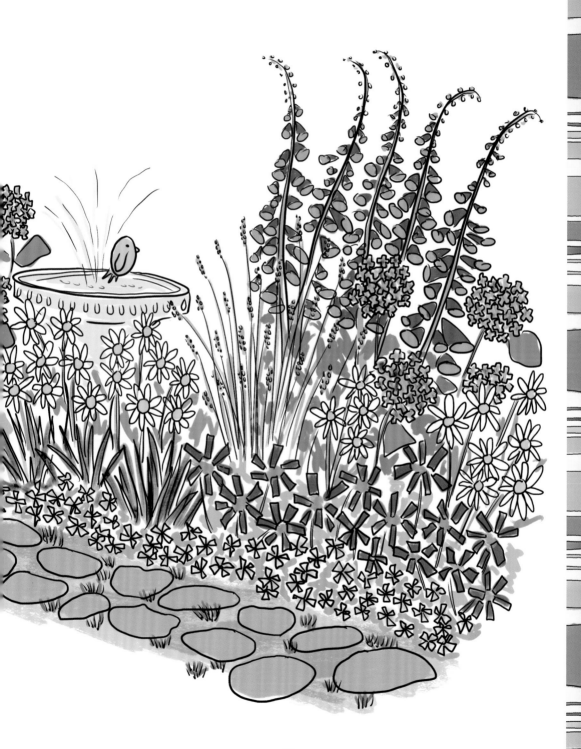

Project 4:
YOUR NEIGHBORHOOD

Abstract illustration uses many of the same techniques as abstract fine art—color, line, and shape—to convey an idea. Familiar subjects are

abstracted to geometric forms and remain easy to understand, even with simplistic rendering. A composition can be intensified with exaggerated shapes, colors, patterns, and line work to heighten the meaning of an illustration.

Medium: gouache

For this project, let's stay local and create an abstract illustration representing your own neighborhood, observing the colors of the neighboring houses, the curves and shapes of the roads, and any other distinguishing features that give your neighborhood character.

Abstract Warm-Up:
CREATE AN ABSTRACT HOME

Let's start by practicing some techniques to create an abstract illustration of a single home.

INITIAL SKETCH

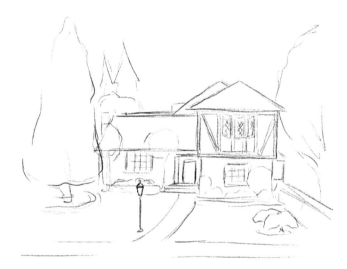

Start with an initial, representational sketch. This is my childhood home. It's a late 1920s Tudor-style and saw many years of our family life, from birthday parties to large family celebrations like my sister's wedding. It's a very traditional home, so creating an abstract version is less about what it actually looks like and more about the energy, vibrancy, and memories it represents.

ABSTRACT SKETCH

Using your initial sketch as a reference, study the basic shapes of the house and recreate the sketch with geometric forms, such as triangles and squares. To add playfulness, I intentionally skew and flatten the dimensionality to play up the shapes. I emphasize the defining elements. For the landscaping, use a variety of clean, organic shapes and lines.

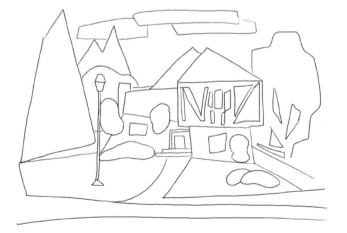

COLOR BLOCKING

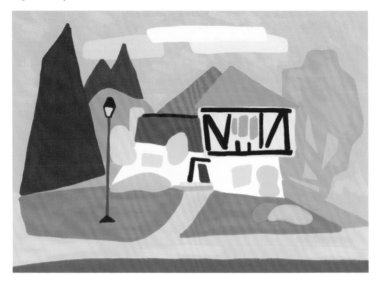

Now add color. Choose colors not based on the actual home but on your impression of the house. Using gouache paint, begin to block in areas of color. Don't worry about staying in the lines of your sketch. Let the shapes and colors overlap and layer on top of each other.

ADD PATTERNS & PERSONALITY

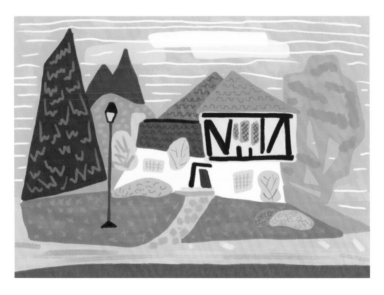

Once the first coat has dried, add details. Have fun and use expressionistic strokes. Continue to add painterly marks or playful patterns to indicate relationships with other shapes in the piece. In the end, the illustration clearly reads as a house, but one that is filled with much more personality than a traditional drawing.

CREATE YOUR NEIGHBORHOOD ABSTRACT ILLUSTRATION

Now apply these techniques to illustrate an abstract impression of your neighborhood.

STEP 1: DEFINE YOUR NEIGHBORHOOD'S COLOR PALETTE

First, come up with a suitable color palette that represents your feelings. Grab your sketchbook and colored pencils, and walk around the block. Scribble down the colors of the houses you see. Are they all neutral? Do some have a pop of color? Perhaps your neighborhood is filled with pine trees or colorful gardens. Are there many mailboxes or stop signs? Capture the color of these items in your sketchbook.

Study all the colors and decide which best represent the way you see your neighborhood. Feel free to interpret or change colors to fit your view as needed.

STEP 2: CREATE AN ABSTRACT SKETCH

Now create an abstract sketch of your neighborhood. To capture the overall sense of my neighborhood with its hills and vistas, I use a bird's-eye view and take the liberty to skew perspectives, foreshorten distances, and heighten hills to fit my viewpoint.

STEP 3:
COLOR BLOCKING

Next use gouache paint, or the medium of your choice, to begin filling in color. I find it's sometimes easiest to paint from the back to the foreground.

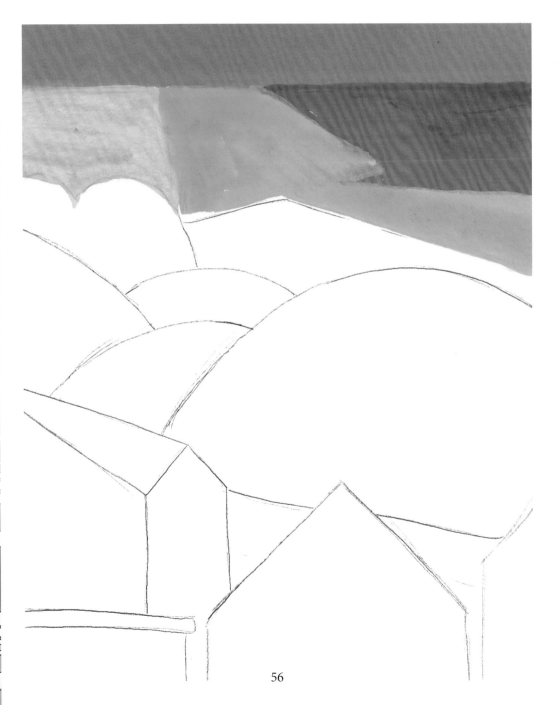

Working from the back, continue to fill in the shapes with color.

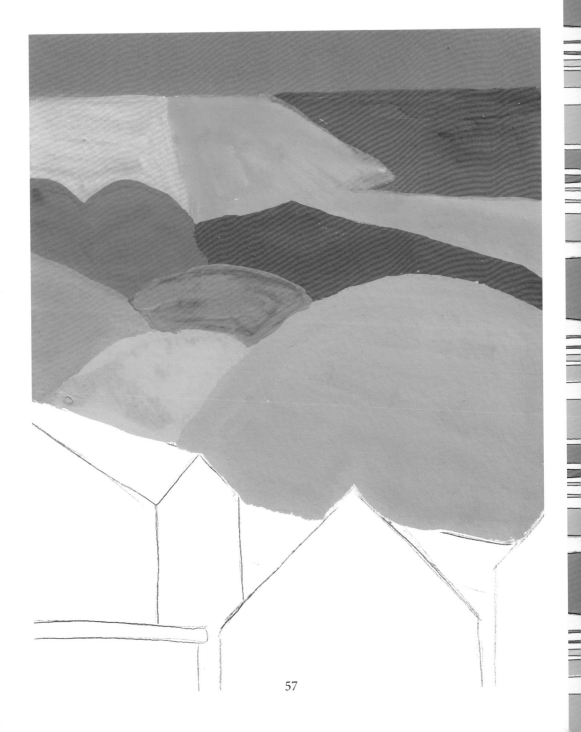

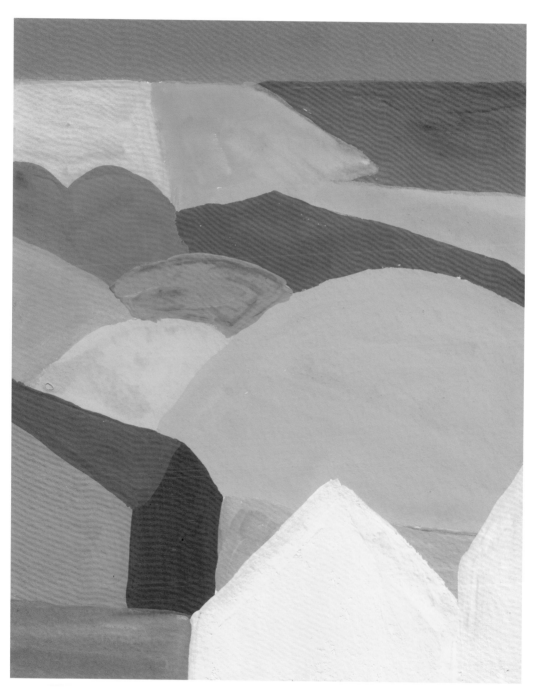

Work all the way to the front of the scene.

STEP 4:
ADD PATTERNS & DETAILS

Use your imagination to fill in the details. Gridlike lines can become neighborhoods in the distance. Hash marks and/or short strokes can indicate a grassy knoll, field, or yard. Try gestural brushstrokes to add other textures and dimension. Keep it as loose and conceptual as possible, but most of all have fun!

59

Project 5:
STATE OR REGION

There is so much to celebrate about where you live. Perhaps you live in California and love the year-round sunny weather, or maybe you're in Louisiana and can't get enough of the flowering magnolia trees. Let's look at a variety of inspiring examples to see how various media can create different effects.

Medium: mixed media

STATE COLOR & SYMBOL ILLUSTRATION

We'll start with a simple drawing using black ink and gouache to create a bold illustration of the state of Texas.

Draw the outline of the state's shape. There's no need to be meticulous; the general shape is typically fine, as many states (and countries) have very recognizable shapes.

TIP

Search the Internet for your state's colors, symbols, and flowers. It's amazing how many "official" symbols are assigned to a single state!

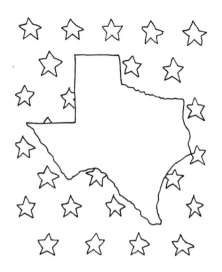

Using the colors and symbols of the Texas flag (red, white, and blue with a single star) as inspiration, fill in the background with large stars.

Add some bold color. Fill in the state with blue and the background with red, leaving the stars white.

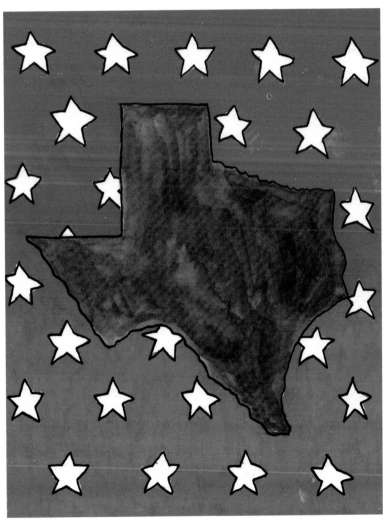

STATE FLOWER ILLUSTRATION

Let's use a limited palette of five colored pencils to create an ode to the wild sunflower of the state of Kansas.

Start by drawing the shape of the state. This one is very easy—it's almost a rectangle! Add a banner at the top for the state name.

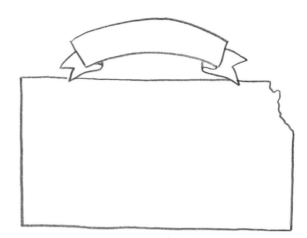

Fill the state with sunflowers! For each bloom, draw a simple circle and put some criss-crossed lines in the center. Then add petals around the edge.

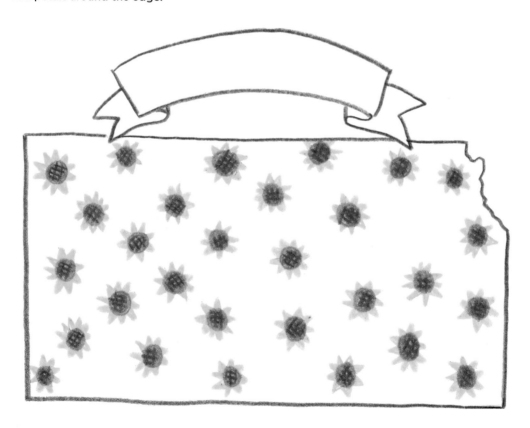

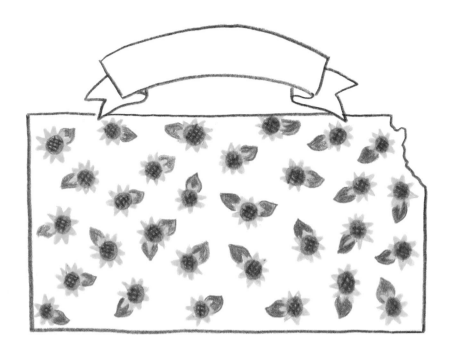

Add a basic leaf shape to each flower to give the illustration more dimension and interest.

Lastly, use a light green pencil to color in the state, and add the name. This cheery illustration would look right at home hanging in a Kansas farmhouse!

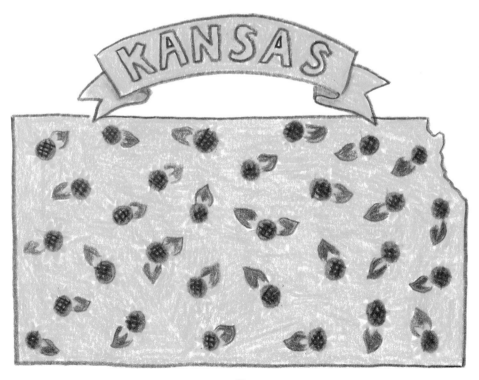

FOOD ILLUSTRATION

Let's take another approach and focus on negative space—essentially drawing only the background and leaving the state blank. For this graphic illustration, you only need three markers—orange, green, and turquoise—to represent the tropical feel of Florida.

First, draw a very faint outline of the state's shape.

Next, add some simple oranges around the outline—just draw circles with leaves.

Use the turquoise marker to fill in the background. For an extra touch, you can put a heart close to where you live or perhaps somewhere you have vacationed!

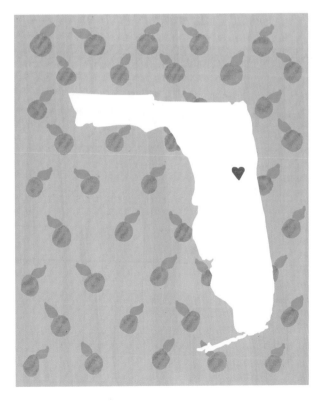

LANDSCAPE ILLUSTRATION

Let's illustrate the desert landscape of Arizona using black pen and watercolor to draw the state that's filled with playful cacti.

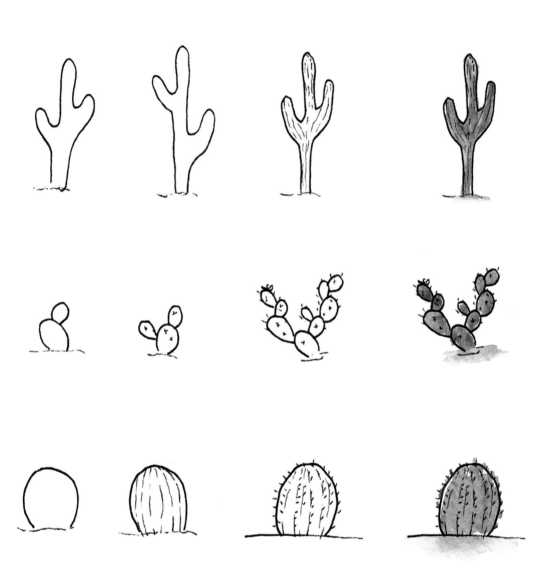

Here are some simple ways to draw three types of cacti that you can use to fill in the state illustration.

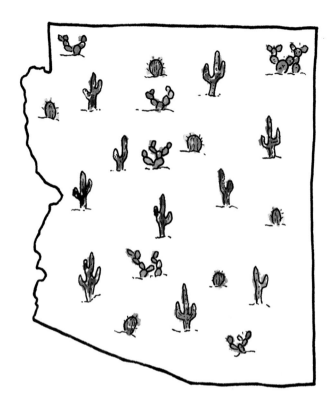

Start by drawing Arizona's shape in black pen (waterproof ink) on watercolor paper. Fill in the entire state with cacti and paint in some quick color.

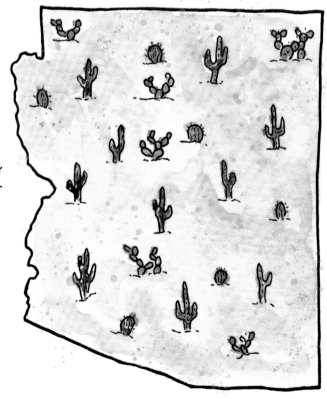

Now add more loose watercolor strokes to paint the sandy background color. I add some paint splatters for a little interest and texture.

Arizona

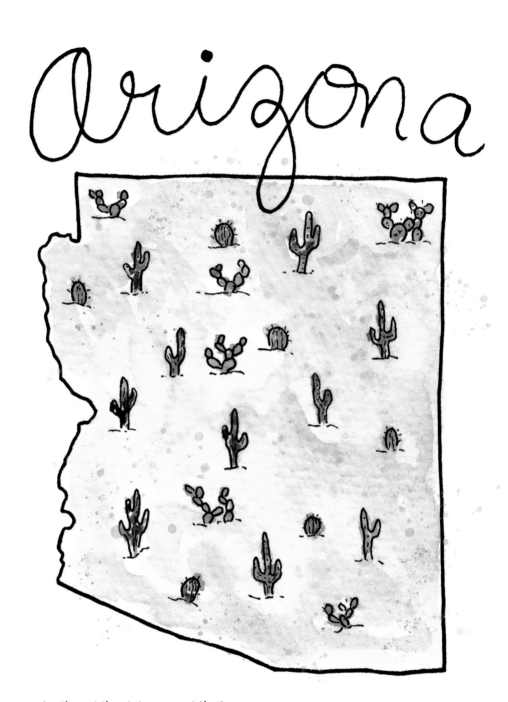

Lastly, put the state name at the top.

COUNTRY ILLUSTRATION

Now commemorate a recent trip and illustrate a country you've visited or one that's on your bucket list! Use the techniques we've explored, or create your own. You can also denote where you traveled with a dot or star. Here's an illustration I created in colored pencil to celebrate a trip to Italy.

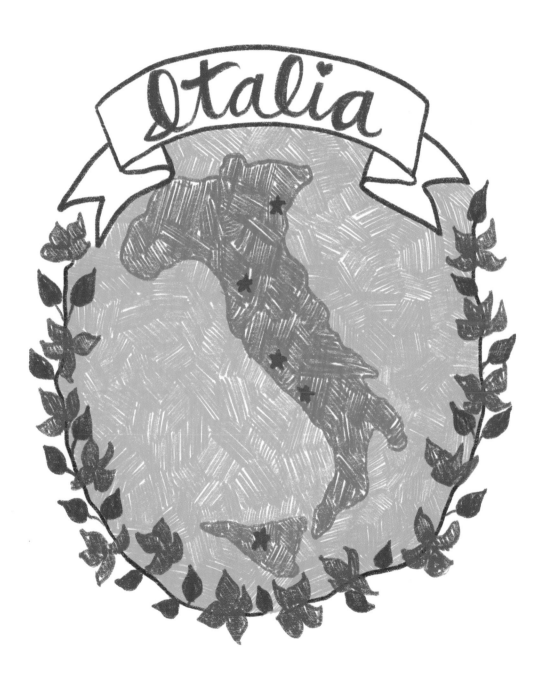

Project 6:
COLLECTIONS

So often on a trip I see just the big things: the landmarks, the parks, the museums. I come home with loads of photos, and a souvenir or two, but they never fully capture the memories of the trip. For this project, let's explore capturing those little details by pretending to be "scientific" illustrators and drawing the elements that represent the collective feelings of a travel experience.

Media: black pen & watercolor

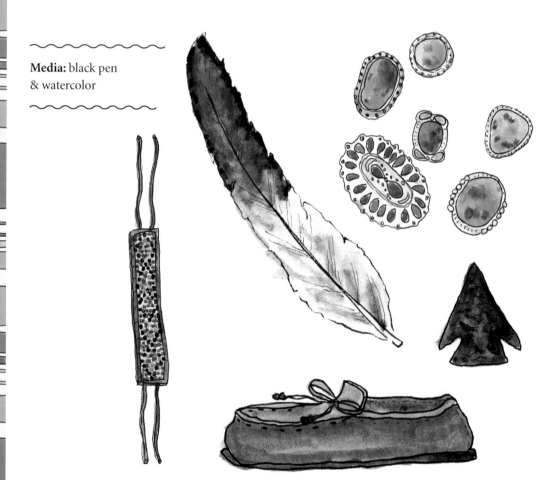

Southwest Collection

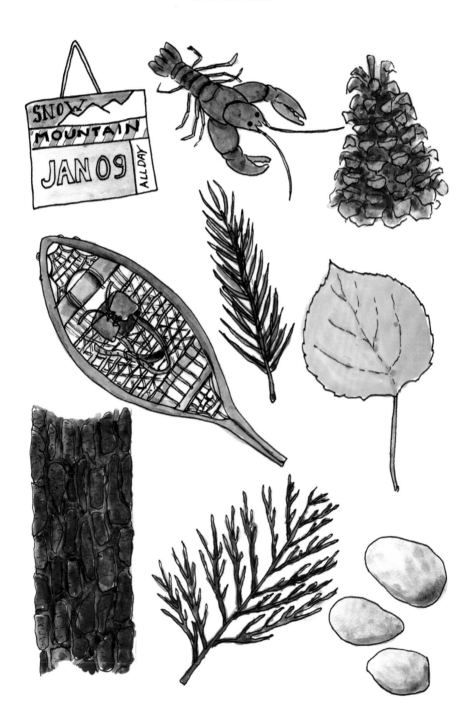

CREATE A "SPECIMEN" COLLECTION

A trip to Hawaii, or any tropical setting, is one you'll never forget. The warm waters, the shells, the sweet fruit, the trade winds—there are so many things that make the tropics special. For this project, use vintage scientific illustrations as inspiration.

STEP 1: DISTRESS YOUR WATERCOLOR PAPER

To give the illustration a vintage feel, first apply a very light wash of brown on watercolor paper. Using a large brush, paint the entire page with water. Use enough water to make the paper visibly wet without pooling. Then lightly put your wet brush in brown watercolor, and dab the brush onto the wet paper. The color should bleed into the wet areas. Continue to add very light brown paint and water to get the desired effect.

TIP

Instead of distressing paper with paint, you can also work on an old piece of paper that has yellowed or aged.

STEP 2: DRAW THE COLLECTION

Now it's time to use a waterproof black pen to draw the "specimens," or little things from Hawaii that make it so unique: a lava rock, a plumeria flower, a pineapple slice, a shell, a palm frond, a coconut, a fish, a tiki statue, and sand.

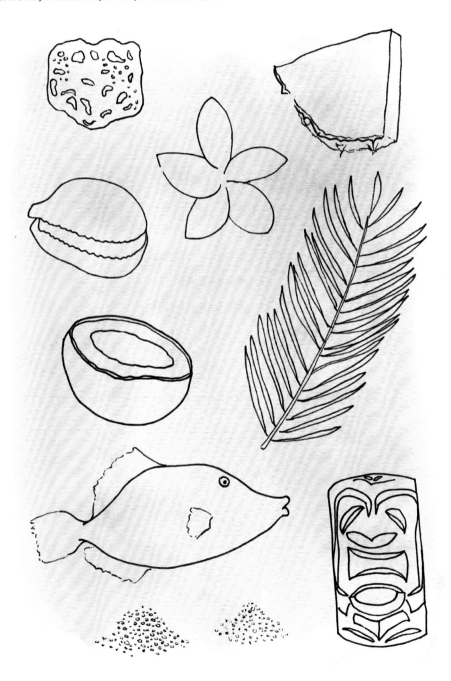

STEP 3: DRAW THE DETAILS

The key to adding details to each drawing is to think scientifically, or to draw the item to help explain certain intricacies. Here are the things that I try to capture:

• Lava rock: rough texture filled with holes and sharp edges

• Plumeria: close-up of the flower's fragrant center

• Pineapple slice: fibrous interior texture

• Shell: both the smooth and rough texture

• Palm frond: the spiky edges

• Coconut: the hairy, hard exterior and chewy, dense interior

• Fish: the shape and textures of the scales and fins

• Tiki statue: the carved features and expression

• Sand: the density of grains, comparing black and white sand from two beaches

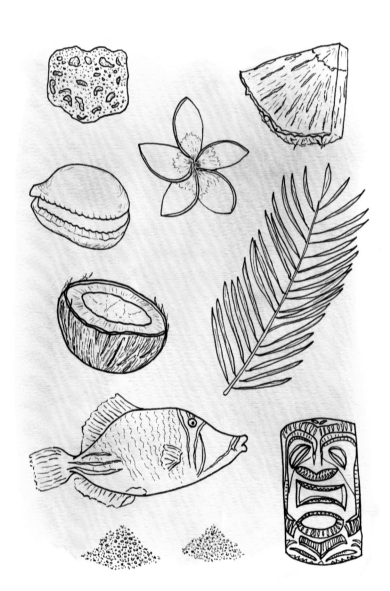

STEP 4: ADD COLOR

The last step is to add color. Using watercolor, mix vibrant colors and paint the objects so that they "pop" off the page, enhancing each object's definition. Once finished, you can frame the illustration and make the perfect memory of your tropical vacation.

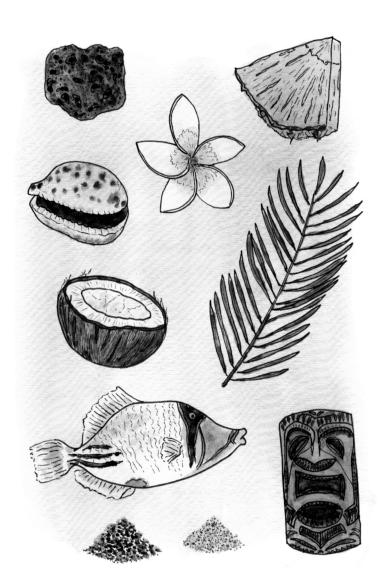

~~~ **TIP** ~~~

*To make the illustration more reminiscent
of a scientific or anthropological discovery,
label your items with their scientific names or species,
as it applies to your collection.*

# Project 7:
# REPORTAGE ILLUSTRATION

*Reportage illustration is the perfect style to use while traveling.* It's easy for me to shy away from including people in my travel sketches, because drawing them can be hard! But people also make travel exciting. Whether it's experiencing a bustling market or relaxing in a park, capturing people is essential to giving my work life!

Reportage illustration is a type of visual "journalism." The goal is to capture the people at a location and some element of the context: mood, emotion, movement, story, and so on.

**Medium:** watercolor pencils

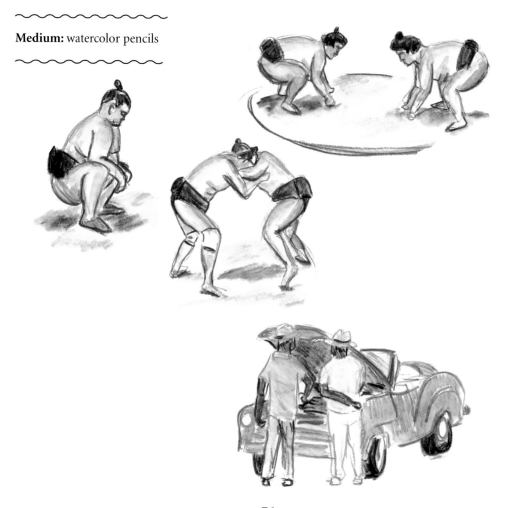

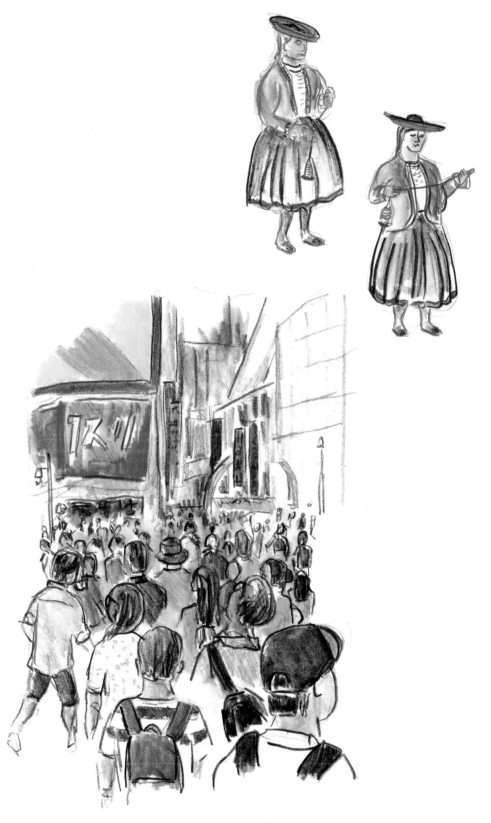

# BASIC HUMAN FIGURE DRAWING

An adult is typically seven to eight heads tall. At the shoulder, he/she can be up to three heads wide. The elbows bend close to where the waist bends. The hands hang about mid-thigh, and the wrists are at the very top of the legs, right below the hips. The torso (neck to hips) is roughly three heads high. The legs, including the feet, are another three heads high. (This may vary if someone has longer legs or a longer torso.) The thighs are slightly longer than the calves.

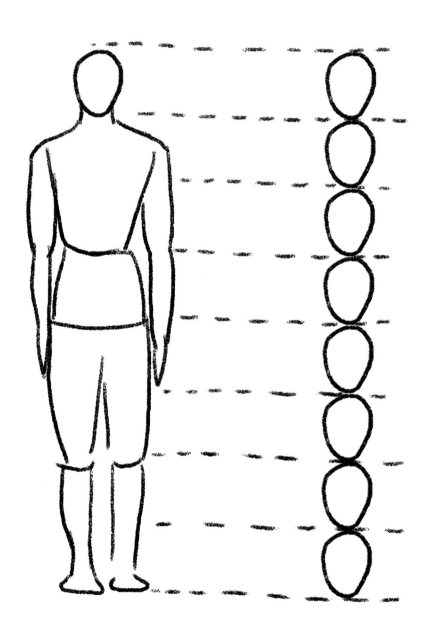

To make drawing the human figure simple, start by drawing stick figures in motion. The more you study and practice drawing the figure, the better you'll become at accurately portraying people. As an illustrator, you are free to exaggerate or use your imagination when interpreting a scene, but some level of accuracy in proportions, weight, movement, and structure provides believability.

Here are some common positions you may find people in when out and about. These sketches show the basic elements of the figures, proportions, and movement.

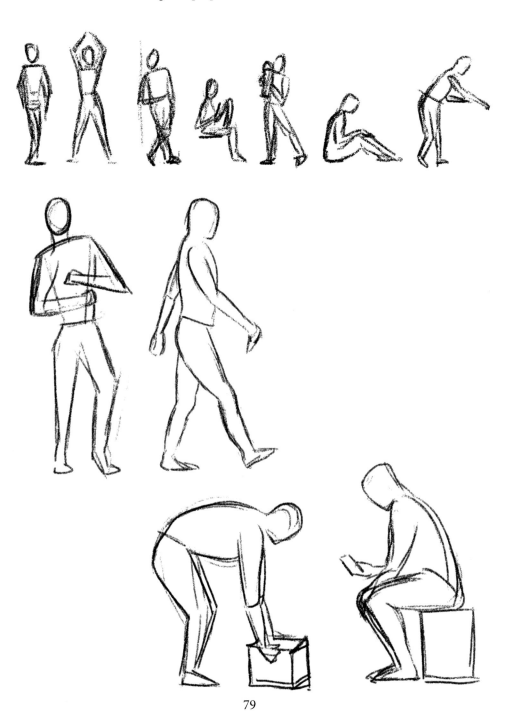

# CAPTURING THE SCENE AT A BUSY FARMERS MARKET

Visiting the local food or farmers markets is one of my favorite things to do when traveling. Shoppers browse for goods, talk to vendors, and make purchases. Vendors chat with customers, rearrange displays, and stock items. The hustle and bustle may seem hard to capture, but we'll break it down into easy steps, using watercolor pencils. They're easy to bring anywhere, and with just a few strokes of water you can activate the pencil marks to become fluid and add movement and motion to capture the energy of the scene.

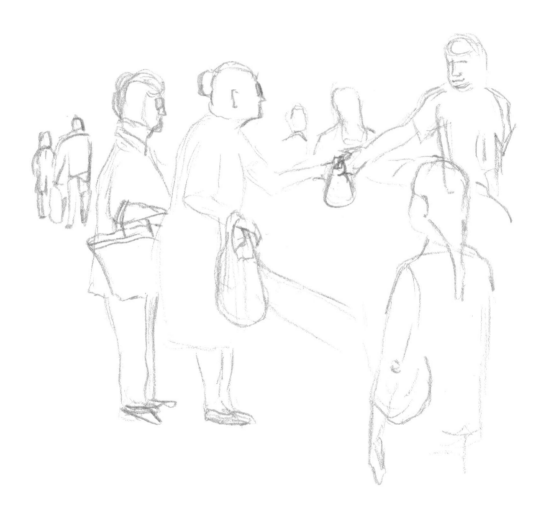

Select just a handful of watercolor pencils to represent the market. Begin by adding some of the key people you see. Since people move fast and don't often linger long enough to pose for your drawing, first create some gestural marks and fill in the rest later.

80

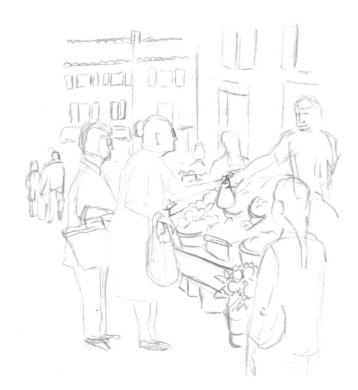

Before adding details to the people, add some key elements of the specific booth or area of the market you're capturing. Again, just use very loose lines.

Next, begin to add more color and details to the people by adding their clothes, things they're holding, their stance, etc.

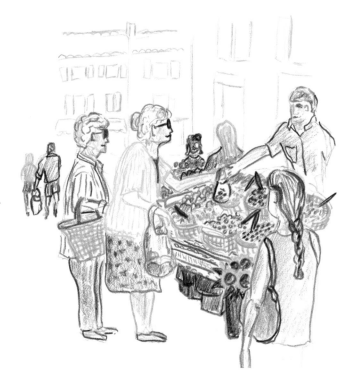

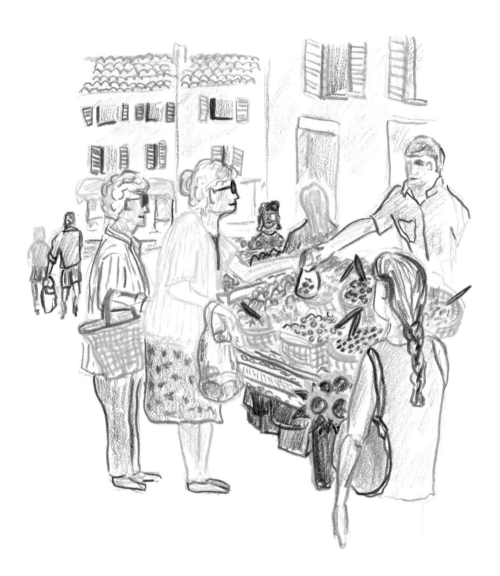

Add more context by continuing to embellish the scenery. Feel free to improvise by adding elements that aren't necessarily in direct view but add more meaning to the overall illustration.

~~~ **TIP** ~~~

Add phrases or words to your art. This gives energy to your illustration, and it's also a great way to remember the details of the day.

The last touch is to use a water brush to "activate" or make some of the watercolor pencil marks fluid. The brushstrokes help provide movement and activity to the scene. It's also important to maintain some of the pencil marks to keep visual interest and show elements that are persistent in the scene.

Once complete, your illustration should truly capture your excursion to the market.

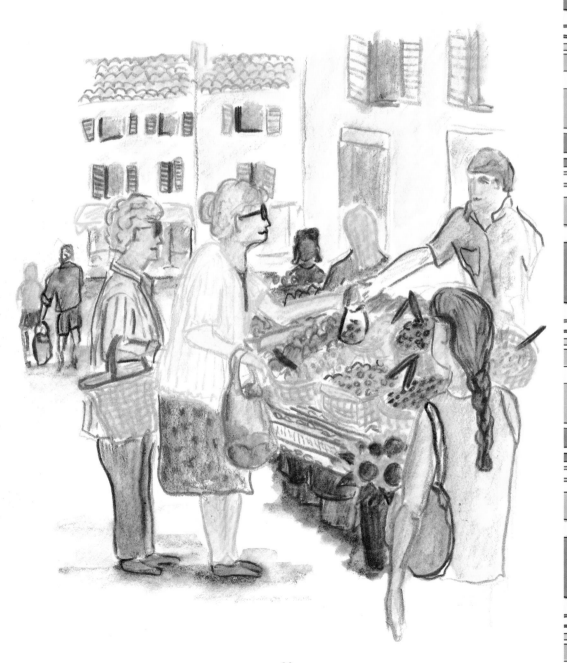

Project 8:
MEMORABLE MEAL

Food is a huge part of travel. Whether it's the distinctive flavors, the unique preparation, or just a spectacular meal, food really can define an experience.

Medium: gouache

TIP
A great outing in a foreign country can be a visit to a local grocery store! Browse the aisles to learn about interesting foods and different styles of packaging.

While traveling in Peru, I learned that more than 4,000 varieties of potato grow in this country, and they are cooked in hundreds of different ways. I loved exploring the local market and sketching a few of the varieties.

You don't need to travel to a different country to find unique food to illustrate. I love to seek out the signature food in any location, whether hunting down the best deep-dish pizza in Chicago or savoring a fresh lobster roll in Maine.

Another item I look for when traveling is beverages, such as coffee and tea. Many countries have their own blends of these drinks, as well as customs on when and where to share a beverage. Taking high tea in London is quite an experience, with fancy dishware, assorted finger sandwiches, and tiered cake stands filled with treats.

TIP

Discovering a local cocktail is a fun adventure. At a bar or restaurant, order a signature cocktail. Then illustrate it on a cocktail napkin for a perfect keepsake!

THE ART OF A JAPANESE DINNER

I once enjoyed a wonderful meal at a restaurant in Japan, which was as much about the food as it was about the presentation. The dinner comprised several small plates and bowls of artfully placed food.

STEP 1: LAY OUT THE DISHES

To start this gouache painting, complete a rough pencil sketch of all the dishes. (Gouache paint is opaque and you'll paint over these lines.)

STEP 2: PAINT THE DISHES

Paint the bowls and dishes over the pencil sketch. I use varied colors.

Embellish some of the dishes with decorative motifs.

To finish the background, add some lines to represent a wood placemat.

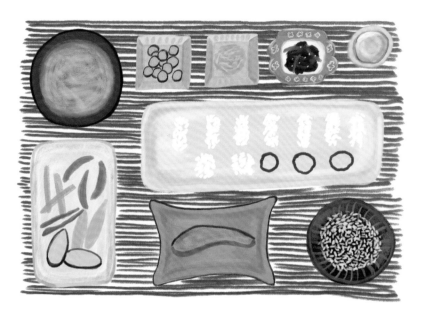

STEP 3: ADD THE FOOD

Now add the colorful food to each plate and bowl. I use simple brushstrokes for many of the foods, including miso soup, pickled cucumbers, pickled squash, steamed spinach, tea, tempura vegetables, sushi, salmon, and rice.

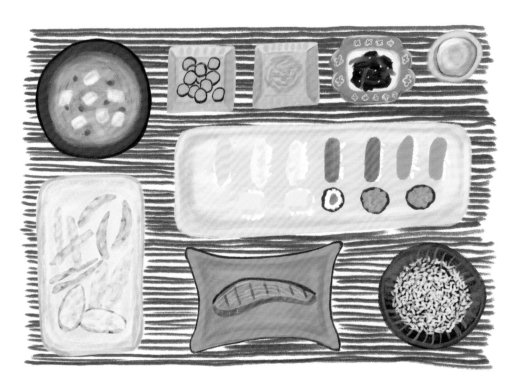

STEP 4: ADD DETAILS

Add more details using large brushstrokes to represent the tofu and green onions in the miso soup, the tempura batter on the vegetables, the raw fish on the sushi, and detail marks on the salmon.

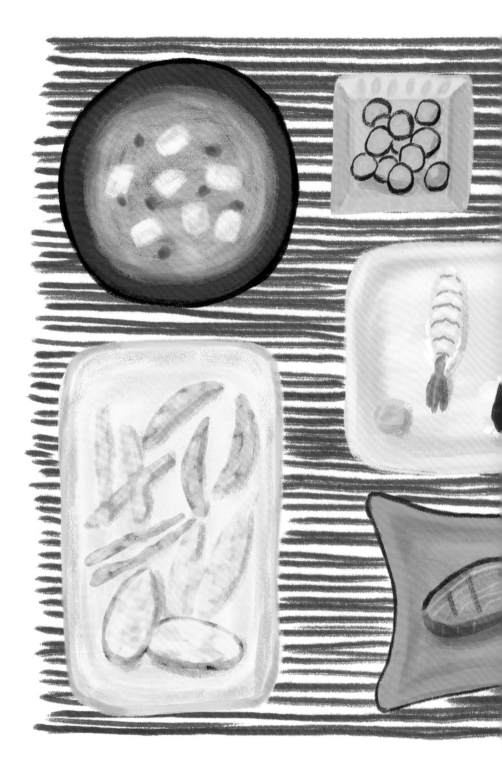

For the final touches, add more details to the sushi, such as seaweed decorations and definition to the various fishes. Finally, use very watered-down gray to add a slight cast shadow to the various foods. This gives a little more depth to each item.

90

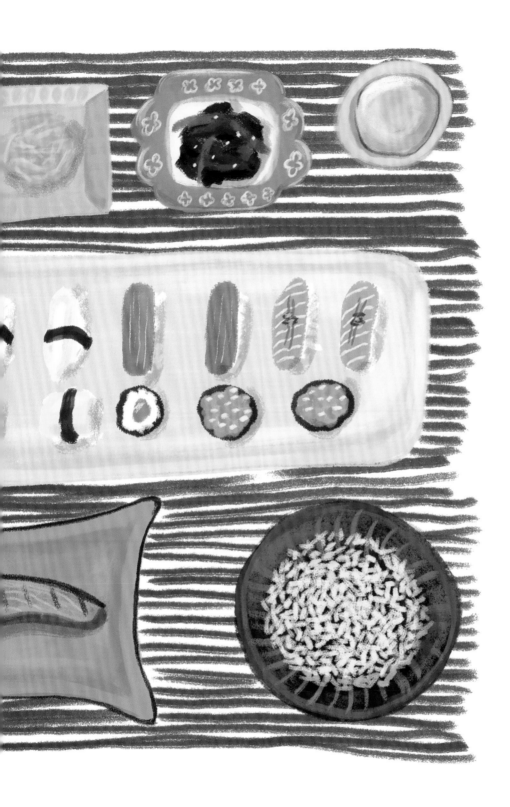

Project 9:
FASHION

Even with photography's domination in the fashion world, there has been a resurgence of fashion illustration. Today, fashion designers use expressive illustrations to further enhance their signature look. We also see fashion illustrations on product packaging, in magazine ads, and as illustrative art prints. The saturation of photography on social media has brought opportunities to be more creative and instead of snapping another selfie of "what I wore," many excite their audiences with an alternative view—like an illustrated version of their outfit!

Media: black pen & watercolor

LA MODE DU JOUR

Fashion illustration is a skill that can take lots of practice and time to learn, but have no fear! For the purpose of capturing the fashions we see in daily life or on our travels, we'll keep it simple. Here are some high-level tips and things to keep in mind when drawing fashion.

1. Drawing People in Clothes— or Just Clothes

Typical fashion illustrations are drawings of stylized models in outfits. Sometimes drawing people can be intimidating, but there's no reason why your fashion illustrations must include a person.

2. Shape, Drape & Weight

A key element in illustrating fashion is understanding the type of fabric the clothing is made from. For instance, a bulky hand-knit winter scarf has a very different look than a silky patterned scarf blowing in the wind. Before you start your drawing, think about how the fabric feels. Depicting different weights, shapes, and drapes of fabric is as easy as a few curvy lines for a silky fabric or straight lines for a stiffer fabric.

3. Pattern/Color

One of the most eye-catching elements of fabric is the pattern or color of the material. When depicting patterns like stripes or plaid, remember to consider the drape and weight of the fabric to make sure the pattern looks somewhat realistic. The draping and weight of the fabric also affect the color by creating shadows where the fabric folds and bends.

4. Texture

The texture of the fabric is also an important element not to overlook. Use crosshatching to indicate a weave or mark-making to show that something is knitted.

5. Details

Of course, don't forget the details! They can make such a difference in an outfit. Buttons, zippers, collars, sashes, belts, pleats, ruching, cuffs, embroidery, sequins, and much, much more! All these little details in a piece of clothing make it even more unique and memorable.

THREE GLOBAL-INSPIRED FASHION MINI PROJECTS

Walking the crowded streets of trendy Harajuku, in Tokyo, provided a wealth of inspiration. These drawings were inspired by fashion-forward youth wearing bright outfits.

Use a black pen to draw a few quirky pieces. Don't forget to add the accessories that make this outfit even more unique!

Finish with bright
watercolors!

~~~~~~~~~~ TIP ~~~~~~~~~~

Remember the accessories when drawing fashion,
whether it's jewelry, shoes, a hat, or an umbrella.

97

## Fashion Inspired by the South of France

Some fashions stand the test of time and are true classics—like these essentials you might see at a French beach.

Include accessories, such as a hat, sunglasses, and bag.

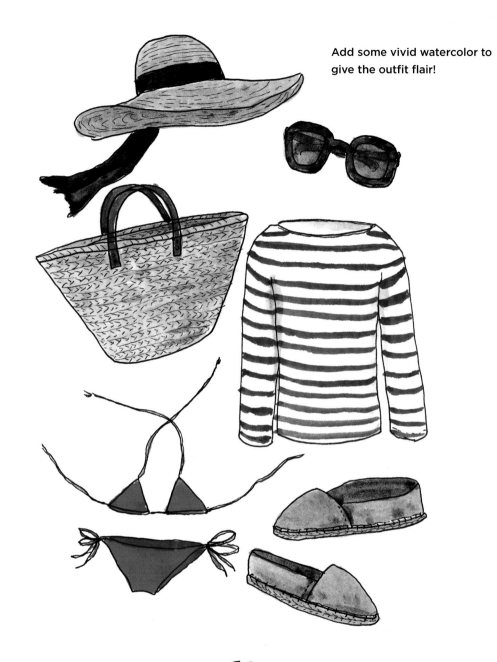

Add some vivid watercolor to give the outfit flair!

## TIP

Browse a local boutique or big department store. Take note of how clothes and styles vary. Do certain colors stand out? Are there trendy patterns? Take out your sketchbook and make some drawings!

## Traditional Fashions

I love traditional clothing and outfits. I will never forget seeing a little boy in lederhosen wandering about during a trip abroad in Germany.

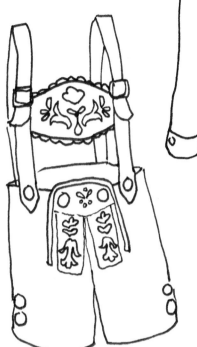

Let's capture this traditional Bavarian outfit for a little boy. First, draw the lederhosen and shirt.

Add some accessories.

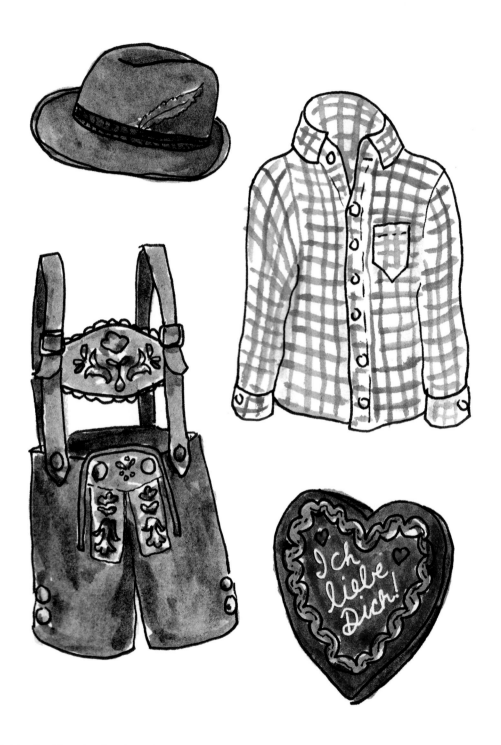

Add a final touch of watercolor.

# Project 19:
# WORD ART

*Hand lettering is a popular form of illustration.* Even with the infinite array of digital fonts and typefaces, there's something about hand-lettered words that adds a unique and personal touch to an illustration. You can add lettering to any piece, change elements of a letter, add swoops and swirls, and embellish to your heart's content! Hand lettering can be part of a larger illustration, like a title, or it can be the illustration itself, like a quote.

**Medium:** colored pencil

## HAND-LETTERING BASICS

Before we dive in, here are some basic elements of lettering.

A: Ascender or Cap Line

B: Descender Line

C: Baseline

D: Midline or Mean Line

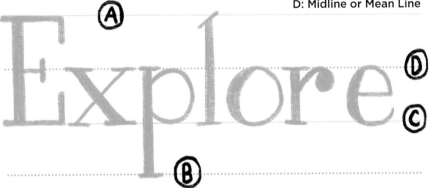

*~ TIP ~*

*Hand lettering gives illustrators a lot of freedom to create letters in different ways, but always keep legibility in mind. Even if your word or quote is a creative masterpiece, if it's not readable, it won't be successful.*

## BASIC STYLES OF LETTERING

Here is the word "wander" lettered in four different styles (from top to bottom): serif, sans serif, script, and illustrative. It's amazing how each style can give new meaning to the word. When creating a hand-lettered illustration, the look of the lettering is something to keep in mind— whether it's bold and blocky or thin-lined and frilly, the style affects the meaning of the word.

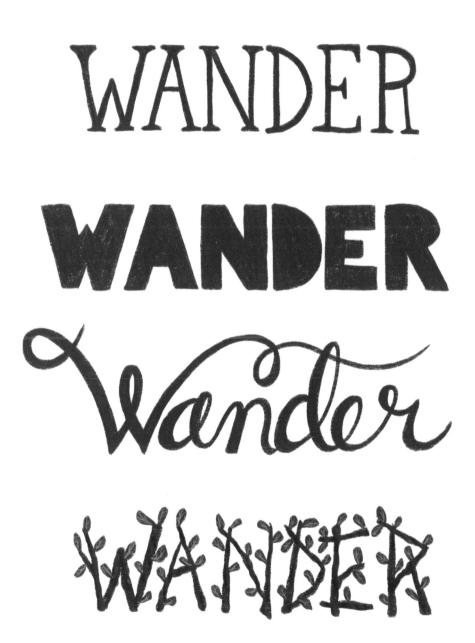

# HAND LETTER A PROPER NAME

Now let's dive into some mini projects and explore three different ways to letter a city or country name. These are the perfect illustrations to use as a cover page of a travel journal or as beautiful standalone art prints to hang on your wall and remember a favorite city.

## City Name with a Monument or Icon

One of the most memorable icons in the world is the sparkling Eiffel Tower in Paris, France. For this mini project, let's letter the word "Paris," and replace the "i" with the Eiffel Tower.

---

### TIP

*Think of the ironwork and details of the structure as inspiration when drawing the letters surrounding the monument.*

---

First sketch the letters lightly in pencil, leaving space for the Eiffel Tower. Consider the iron-work—it has many angles, but there are also beautiful curves (the arches at the bottom and the graceful curve of the entire structure). I incorporate this feeling into the "P," "a," "r," and "s" of my sketch.

Next, lightly sketch the Eiffel Tower.

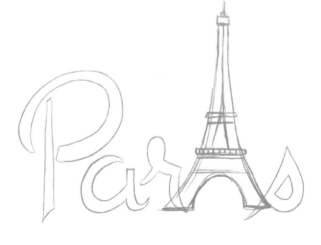

Finish by using black permanent marker to trace over the pencil lettering and monument. Add more detailed lines in the monument. The stark black pen gives the end illustration a classic feel and reflects the city it represents.

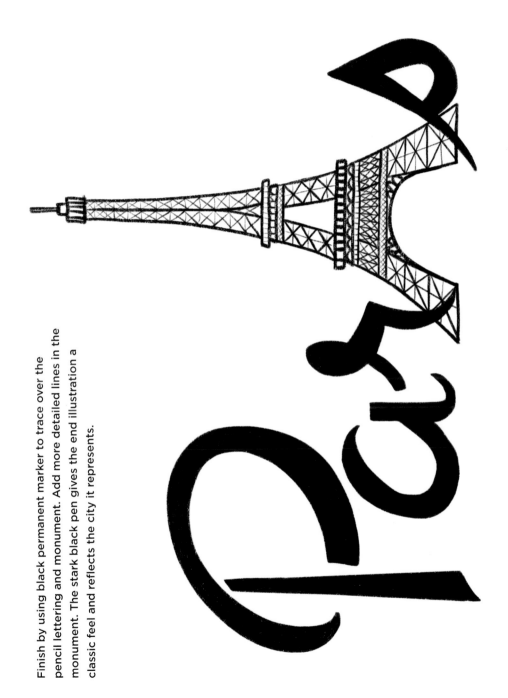

## City Name in a Shape

New York City—the Big Apple—is one of my favorite cities in the world. For this mini project, let's letter New York City in the shape of an apple.

Start by creating the outline of the shape.

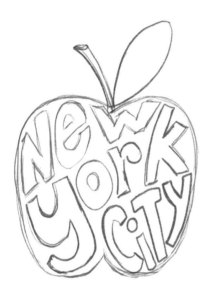

When you're happy with the shape of the apple, add the lettering. Since New York is such a bold city, I use block sans serif lettering. I also take the liberty to experiment with the baseline of the words and have the letters play off each other, which adds just a bit of the chaos or unpredictability that New York offers.

Next, color in the apple and leaf in bright cherry red and green. I don't color in the letters; I keep them blank to allow the white of the paper to "pop" next to the red color.

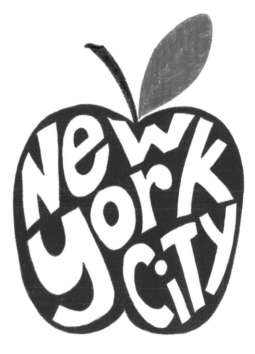

## Country Name, Styled and Embellished

One of my favorite things to do in a new city is check out the signage. Whether it's street signs, subway signs, or restaurant signs, I'll snap photos to remember. It's amazing how each city seems to have its own look when it comes to lettering. The classic, elegant curves and lines of type on a menu in Paris and the modern, bright neon lettering in Tokyo are just two examples. For this illustration, let's draw inspiration from the festive and colorful *papel picado* decorations prevalent in Mexico.

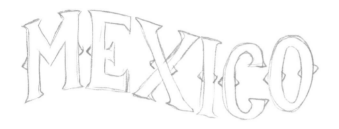

First, draw the outlines of the lettering on a wavy line.

Doodle paper cut-like markings in the outlines of the letters.

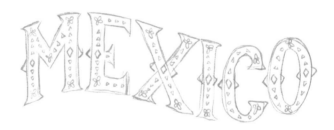

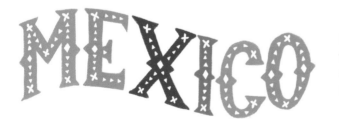

Now use bright colors, like turquoise, orange, magenta, and lime green, to add a big burst of color.

# HAND LETTER A MEANINGFUL WORD OR PHRASE

Words and phrases are an obvious choice for creating illustrations for a travel journal or to commemorate a special trip.

## Word

One of the most beautiful words in the Hawaiian language is *ohana*. It means "family," yet extends beyond blood relatives to include your extended family of friends and loved ones. There's also a larger meaning of how a family is bound together in cooperation and remembrance of one another.

Start by lettering the word. The first thing that comes to mind when I think of Hawaii is, of course, the tropical flowers, trade winds, waves, and beautiful blue water. When I translate this feeling to lettering, I think of a flowing script.

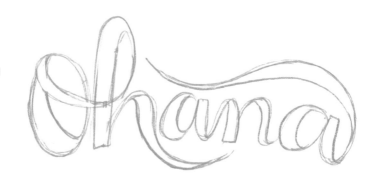

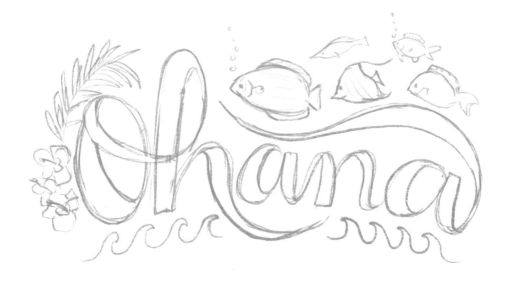

Add a few embellishments. I add some Hawaiian accents and a "family" of tropical fish.

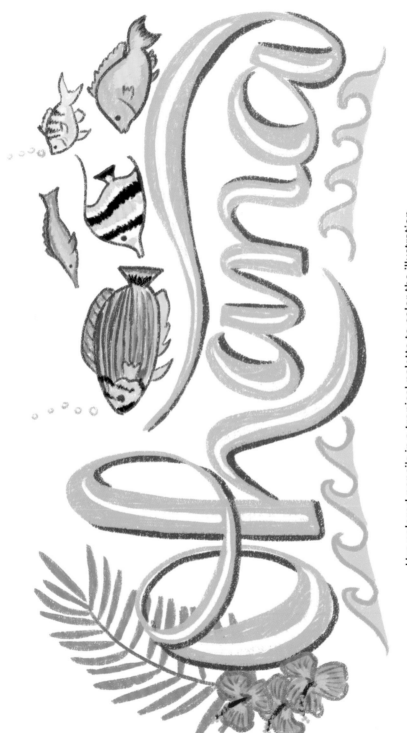

Use colored pencils in a tropical palette to color the illustration.

## Phrase

In your journal, write down phrases you frequently hear while traveling or other well-known phrases and idioms. They can become a memorable part of your experience and are fun to letter.

For this last mini project, I chose *Que sera, sera:* "What will be, will be."

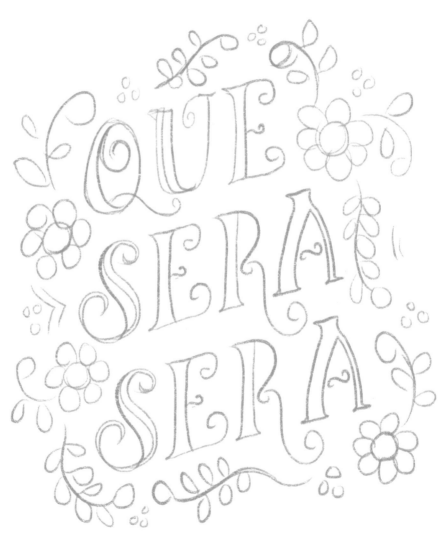

Start with a pencil sketch of the phrase. I've chosen to letter this phrase in a decorative format. I also add some swirls and accents.

*Before traveling to a country, read and learn a little about the culture, attitudes, and everyday life. Many cultures have sayings or mottos that are truly beautiful.*

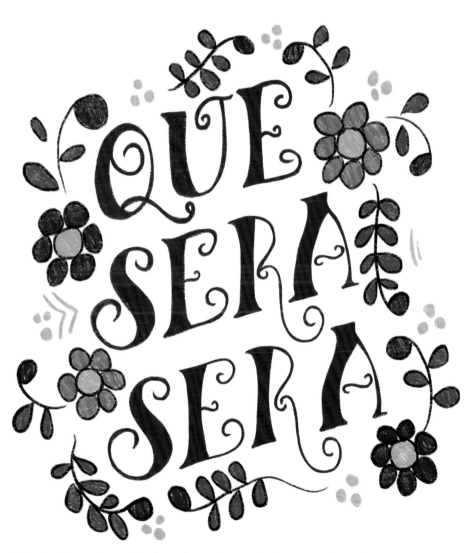

Color the illustration with the palette of your choice. My color palette contains golden yellows, blues, greens, and rust reds.

# Project 11:
## PATTERNS

*Patterns are everywhere! Just glancing around my house, I'm surrounded by them:*
polka dot pajamas, floral throw pillows, chevron rugs, and striped curtains.

I especially love learning about the textile traditions of a country or culture. The patterns may be woven, dyed, embroidered, knitted, quilted, painted, printed, and more.

~~~~~~~~

Medium: multimedia

~~~~~~~~

In Ghana, you can find kente cloth—a brightly colored, geometric and striped fabric.

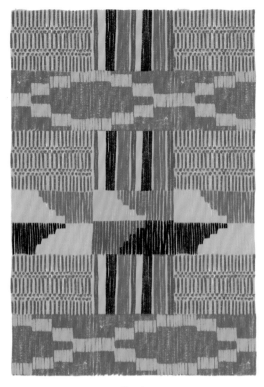

Kente

In Indonesia, you can find beautiful, bright batik fabrics made with a technique that uses wax to resist dye in areas of the cloth, forming colorful and decorative patterns.

Batik

112

Brightly painted Talavera pottery is frequently seen in Mexico.

**Talavera**

Swedish culture celebrates a rich history of folk painting known as "kurbits" that evolved over hundreds of years to folk art on walls, furniture, and more.

**Kurbits**

Now let's explore making some simple patterns of our own.

# TOILE-LIKE PATTERN INSPIRED BY IRELAND

In Ireland, just minutes outside of Dublin, you'll find the hillsides covered in pastoral plots filled with sheep. We'll use this imagery as inspiration for a toile-inspired pattern using watercolor and marker.

First, paint your paper with a very light watercolor wash of green. Allow the paint to dry, and then use a fine green marker to draw a sheep in a pasture.

Add more sheep!

Finally, fill empty areas with pastoral scenes of Ireland: house, grasses/florals, landscape, etc.

# COLORFUL PATTERN INSPIRED BY PERU

Now let's make an Inca-inspired pattern with gouache paint and paint pens.

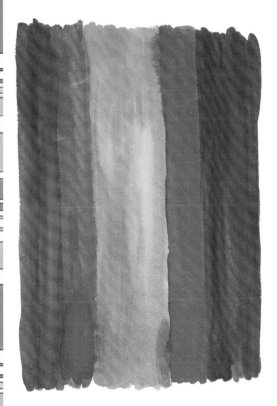

Start with a rich earth-toned palette, and paint gouache stripes on your paper, varying the widths of the stripes.

Once the stripes have dried, use paint pens in complementary colors (either darker or lighter than the painted stripe) and start to draw some patterns.

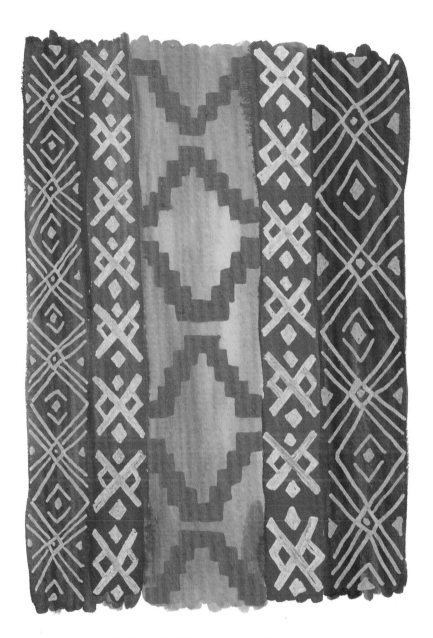

Continue to fill each area until your
pattern is complete.

# IKAT-INSPIRED PATTERN FROM BALI

For our last project, let's create a simple ikat-inspired pattern by using brushstrokes of watercolor. To achieve the "bleeding" or fuzzy visual effect seen in ikat patterns, we'll finish with a simple wash of water!

**Start by painting simple brushstrokes to create a diamond. Repeat this same diamond shape across the entire paper to create a pattern.**

**Use a secondary color to paint loose brushstrokes and lines "framing" each of the diamonds on the page.**

With a third color, add lines to fill the background.

With only water on your brush, add brushstrokes on top of your painted lines. The watercolor below (although dry) will bleed a little to create the "blurry" effect sometimes seen in ikat patterns.

# Project 12:
## COLLAGE ILLUSTRATION

*Collage illustration is a great technique for capturing everyday adventures at home or while traveling.* A simple grocery list, a food wrapper, and a drawing of some vegetables collaged into your sketchbook can tell a unique story of the delicious recipes you made. Likewise, collaging a train ticket stub, pictures from a brochure, and a detailed itinerary can be a great way to journal your day of discovering a new city.

**Medium:** Collage

## ILLUSTRATE ON A TICKET

When I return home from a trip, I love looking through the varied ticket stubs from the tours, transportation, and/or sites I may have visited. They come in all shapes and sizes and have a wide variety of designs printed on them. Don't let the pre-printed designs distract you, though. There are many creative illustrations waiting to be added to this ephemera!

Here are three different ways to embellish a ticket stub to create a memorable keepsake.

### 1. Draw a Silhouette

Using a black pen, I doodled a city skyline on this old subway card. I used a white pen to add the windows of the buildings. I love the way the background designs printed on the card almost become a setting sun behind the skyline.

## 2. Draw a Scene with Marker

This ticket stub is from my bullet train ride in Japan. One of the most memorable scenes along this ride was our view of Mount Fuji out the window. It also made the perfect subject to draw on the ticket stub. Using four different colored markers, I drew a simple version of the famous mountain.

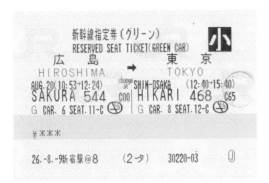 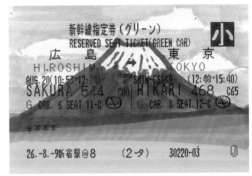

## 3. Paint a Scene with Watercolor

The unique rock formations at the Giant's Causeway in Northern Ireland are a sight to behold. The ticket stub from visiting this World Heritage Site was just the right size to capture a slice of the landscape. With my travel watercolor set, I painted the strange basalt columns jutting up out of the ocean floor.

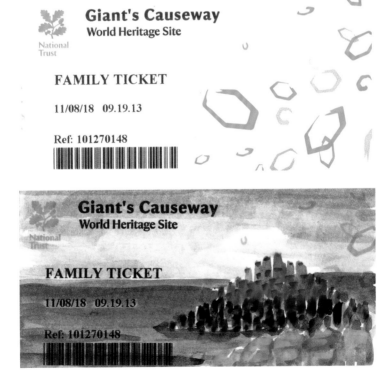

# ABSTRACT COLLAGE

A simple way to commemorate any trip is to create an abstract collage using the various ephemera you bring back home. To start the project, I first gather all the items and pick out a handful that share a similar color palette, yet also have some visual variety. I also pick out one of my favorite elements to be the highlight of the collage illustration—in this case, a tiny origami paper crane.

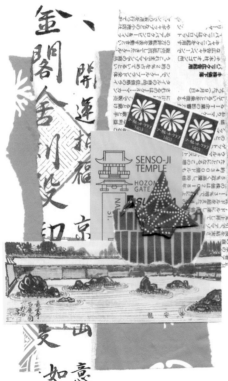

I start to tear up each piece of ephemera into different sizes and lay them on a blank piece of paper. As I tear up more elements, I play around with how best to layer each item and where to place the paper crane. Once satisfied with the arrangement, I use an archival glue stick to adhere each piece to the blank paper.

# COLLAGED LANDSCAPE OF PAINTED NEWSPRINT

This is one of my favorite collage techniques that is used by many of my beloved children's book authors. I love this technique because it not only uses ephemera, or found objects that have their own meaning, but also involves painting and assemblage to create a whole new illustration.

For this illustration, I decide to collage a landscape of spectacular Uluru, the massive Australian monolith that juts out of the outback in the center of the country. The colors of the huge outcrop change throughout the day, and by sunset it glows a rich rust-red. With the simple yet striking palette of the landscape, it's the perfect candidate for a collage.

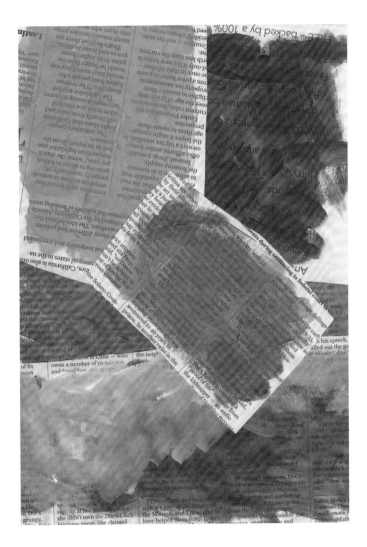

To begin, I gather an assortment of newspaper pages. I look for some variety in type sizes to add visual interest; for this landscape, I intentionally avoid any photos. Next, with a small palette of acrylic paints and a large brush, I spread large swashes of color on each clipping.

Once the paint dries, I get out my scissors and start cutting shapes. I start by creating the sky and land, cutting out the painted areas of the newspaper, and pasting them onto a clean piece of watercolor paper.

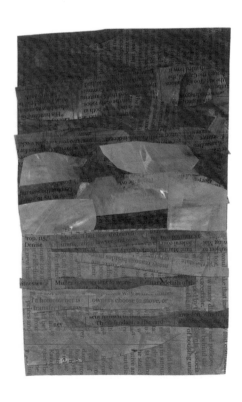

Next, using pieces from the same colored newspaper clippings, I begin to layer and glue random pieces to the sky and land. Although many of these pieces come from the same painted news clippings, the slight differences in color and brushstrokes make them look varied.

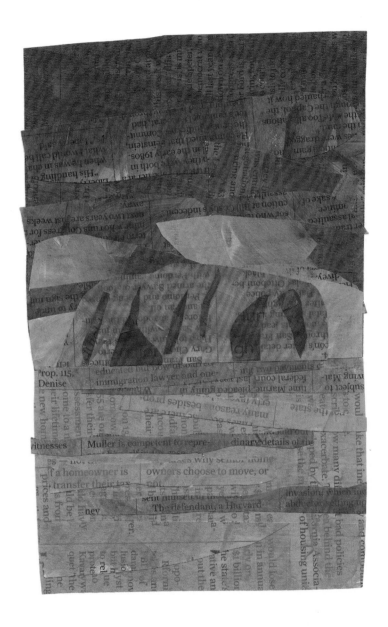

The last element I collage to the illustration is the cut-out shape of the monolith, Uluru. I add some small, detailed organic-shaped lines within the monolith to indicate shadows and/or the slightly undulating surface. With those last touches, my landscape is complete. This seemingly simple collage has a lot of interest, with the subtle variation of colors in the paint, the texture of the brushstrokes, the layering of the newspaper clippings, and the slight hint of text that remains visible.

# INSPIRATION

*I can find inspiration almost anywhere!*
I'm the person who is bent over taking a picture
of a decorative manhole or has her sketchbook
out at a restaurant, drawing the drinks while
we wait for our meal. I can love something
just because of its color—and I definitely get
energized when I talk to an enthusiastic local about places to discover.

In my studio at home, I am also surrounded by inspiration. I have bookshelves filled with eye
candy, a computer filled with websites to drool over, and a host of online illustration friends
I adore and am continually motivated by. Use all of the resources at your disposal to find
inspiration too! Build your own inspiration library of online resources and books on topics that
ignite your enthusiasm and creativity.

# ABOUT THE ARTIST

Having traveled to almost 40 countries and to all 50 U.S. states, Betsy Beier loves to explore the world creatively!

Whether at home in the San Francisco Bay Area or abroad, you may find her sketching a delicious meal in her travel journal, creating a watercolor of the leaves she found on a walk, lettering a quote she overheard in her favorite coffee shop, or illustrating a map of the road trip she just experienced.

*"Taking the time to slow down and illustrate the world around me has opened my eyes to many colorful locations, unique experiences, and friendly people I may not have met otherwise."*

Her love of travel has also allowed Betsy to build a thriving illustration business, including licensing her work on a wide variety of products, including puzzles, home goods, calendars, cookbooks, travel books, and more.

Betsy earned her BFA in painting and drawing at the University of Colorado, Boulder, and her MFA in computer graphics and interaction design at Pratt Institute in New York City. Her design career of more than 25 years has allowed her to wear many hats, from art director at various marketing firms to user interface architect at one of the largest software companies in the world.

She left the corporate world in 2006 to raise her family and explore her own illustration style. Her diverse career path with a wide range of design jobs has taught her that she thrives on learning new skills and pushing herself artistically.

*"I absolutely love grabbing my travel watercolor set and quickly painting a scene, yet also have just as much fun doodling in my favorite painting app on my phone. It's so exciting to have so many varied media readily available and easy to use wherever you may be!"*

For more information about Betsy's illustration work, please visit www.betsybeier.com, and follow her illustrated travel blog and creative adventures at www.wanderlustdesigner.com and on Instagram at @wanderlustdesigner.

# ALSO IN THIS SERIES

978-1-63322-195-6

978-1-63322-270-0

978-1-63322-494-0

978-1-63322-496-4

Visit www.QuartoKnows.com